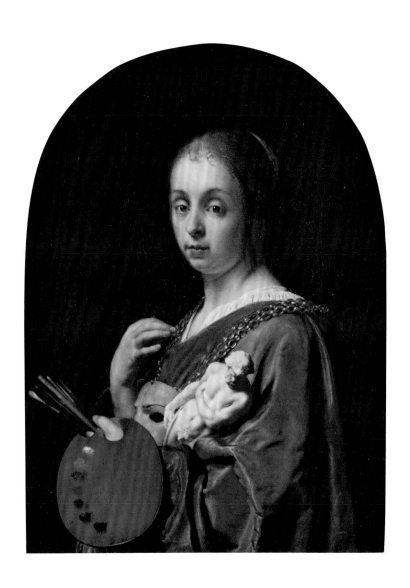

LOOKING AT PAINTINGS

LOOKING AT
PAINTINGS
A GUIDE TO TECHNICAL TERMS REVISED EDITION

TIARNA DOHERTY AND **ANNE T. WOOLLETT**

THE J. PAUL GETTY MUSEUM • LOS ANGELES

© 2009 J. Paul Getty Trust

First edition published 1992
Revised edition 2009

Published by the J. Paul Getty Museum

Getty Publications
1200 Getty Center Drive, Suite 500
Los Angeles, California 90049-1682
www.getty.edu/publications

Gregory M. Britton, *Publisher*
Mark Greenberg, *Editor in Chief*

Library of Congress Cataloging-in Publication

 Doherty, Tiarna. Looking at paintings : a guide to technical terms /
Tiarna Doherty and Anne T. Woollett. -- 2nd ed.
 p. cm. 1st ed. published in 1992.
 Includes bibliographical references and index.
 ISBN 978-0-89236-972-0 (pbk.)
 1. Painting--Dictionaries. I. Woollett, Anne T. II. Title.
 ND31.C37 2009 750'.3--dc22
 2008051139

Printed in China through Oceanic Graphic Printing, Inc.

Contents

Preface to the Revised Edition vii

Glossary 1

Selected Bibliography 89

Index 90

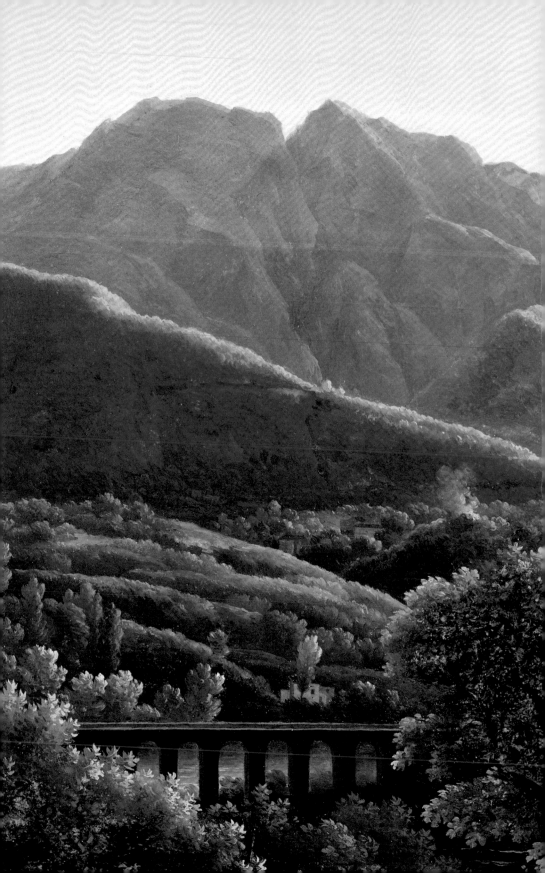

Preface to the Revised Edition

At the time of its publication in 1992, *Looking at Paintings* was a unique reference tool. In vivid and concise prose, Dawson W. Carr and Mark Leonard's original edition helped enrich the understanding and experience of art for museum visitors. It was, and remains, an important model of collaborative art-historical and conservation scholarship.

This new edition reflects the impact of trends in the field of art history and in paintings conservation in recent years. Terms from the practice of conservation have come to inform the discussion and interpretation of paintings in exhibitions and in didactic materials within museums today. A substantial number of terms related to condition and process, both historical and scientific, have been added to the original text. In acknowledgment of the relationship between an artistic form, such as ceiling painting, and technique, the definitions of specific genres of painting have been introduced. A number of key terms associated with twentieth-century and contemporary artistic practice have also been added, though a comprehensive survey would require a separate volume. Most of the illustrations in this volume have been drawn from the Getty's collection of paintings, attesting to the significant growth of the Museum's holdings over the past fifteen years.

We gratefully acknowledge the guidance and support of Mark Leonard and Dawson Carr in producing this new edition, which is, of course, based on their original text. Our colleagues in the Department of Paintings and Department of Paintings Conservation, notably Senior Curator of Paintings Scott Schaefer and Conservator Yvonne Szafran, provided valuable contributions. We thank Associate Director David Bomford for his support and valuable guidance and his contributions to the field of technical art history. We would also like to express our appreciation to colleagues in the Department of Drawings and the Department of Imaging Services. It has been a great pleasure working on this volume with our colleagues in Getty Publications. In particular we would like to thank Editor in Chief Mark Greenberg for proposing a new edition, John Harris for editing this volume, Kurt Hauser for providing the fresh new design, and Stacy Miyagawa for seeing this book through production. To everyone, our thanks.

ACRYLIC

Patrick Caulfield (British, 1936–2005), *Hemingway Never Ate Here*, 1999. Acrylic and collage on canvas, 213.8 × 191.1 × 3.5 cm (84⅛ × 75¼ × 1⅜ in.). © Patrick Caulfield/Tate, London 2009.

Image © 2009 Artists Rights Society (ARS) New York/DACS, London.

Glossary

Note: Words printed in SMALL CAPITALS refer to other entries in the book.

ABRASION

The damage caused by wearing away the surface of a material from contact with another material. When a paint surface is abraded, the paint layer may reveal tiny spots of an underlayer due to the physical disruption of the surface. The paint layer may then appear more matte or thin than it was when first painted. In CANVAS paintings, abrasion may reveal the pattern of the canvas, since the highest points in the woven fabric will be abraded first. Abrasion is a form of damage that may be caused by aggressive attempts at cleaning a painted surface with strong cleaning agents or solvents or by rough mechanical action.

ACRYLIC

A group of synthetic polymers manufactured from compounds based on the esters of acrylic acid and methacrylic acid. While acrylic paints can be manufactured as solutions or EMULSIONS, most are EMULSIONS. The solutions are in solvents and the emulsions are prepared in water, with the addition of surfactants that allow the acrylic and water to mix.

Once the paint has been applied to a surface, the water evaporates, leaving behind the synthetic resin (and PIGMENT), which is no longer water soluble. The water-based nature of acrylic paints allows for easy application and rapid drying time: acrylic paints can dry in a matter of minutes, as opposed to the many months required for OIL-based paints. Visually, acrylic-based paints can appear to be very similar to oil-based paints.

The limitations in using an acrylic MEDIUM include the fact that one is not able to rework the surface with water once the acrylic has dried.

Acrylic paints were introduced in 1936; artists' acrylic paints were introduced in the early 1950s.

Acrylic resins can be used as VARNISH for paintings.

AERIAL PERSPECTIVE See PERSPECTIVE.

AFTER See ATTRIBUTION.

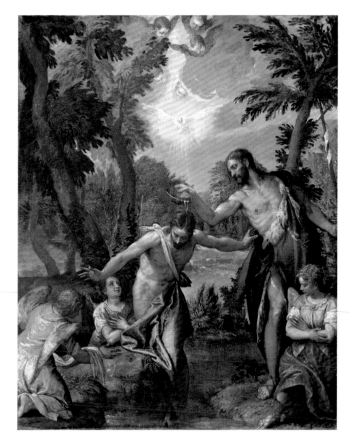

ALLA PRIMA

An Italian term meaning "at first," used to describe a method of OIL painting in which the final effect is achieved in a single, direct application of paint. In contrast to layering the paint with UNDERPAINTING and GLAZING, this technique challenges the painter to create effects with the greatest economy of means, often emphasizing BRUSHWORK. Not necessarily an independent technique, it is often used adjacent to areas with a complex layering of paint. While this type of painting was initiated in the sixteenth century, it was not practiced widely until the middle of the nineteenth century, when painters sought to create the impression of immediacy in their works. The synonymous French term *au premier coup* is more precisely applied to paintings of this period, while the term *direct painting* describes the spontaneous techniques of twentieth-century painters.

ALLEGORY

The representation of an abstract concept or quality by means of figures and symbols. A rich and complex visual language, allegory was used frequently by artists during the Renaissance and Baroque periods to convey a range of meanings through association including, but not limited to, political themes, love, and the senses.

Allegorical symbols and conventions were often derived from classical sources and began to be compiled into reference works during the 1600s to facilitate their use and interpretation by artists and viewers.

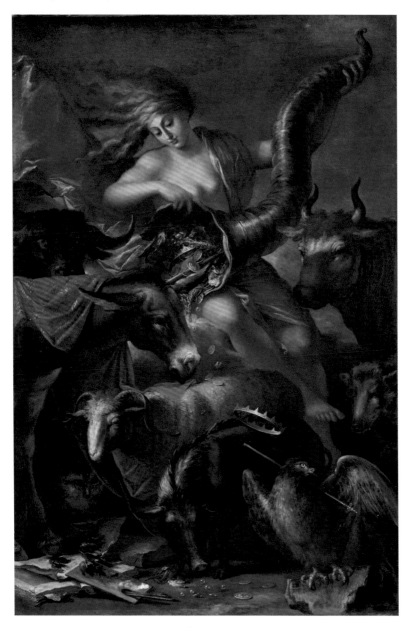

ALLEGORY
Salvator Rosa (Italian, 1615–1673), *An Allegory of Fortune*, ca. 1658–59.
Oil on canvas, 198 × 133 cm (78 × 52⅜ in.). JPGM, 78.PA.231.
Rosa criticized Pope Alexander VII by painting a personification of Fortune lavishing wealth
and power on base animals, which trample the symbols of art and learning.

3

ALTARPIECE

A decorated structure that sits on, above, or behind the altar, adjoining it at the back or giving the appearance of being connected. Also known as a *retable, reredose*, or (in Spanish) *retablo* in reference to its position behind the altar table. The basic form consists of a center panel to which decorated shutters are often affixed. Formats vary widely and can include multiple tiers. Altarpieces may be sculpted, painted, or a combination of both. Small paintings arranged horizontally at the base of the altarpiece form the PREDELLA.

ASCRIBED TO See ATTRIBUTION.

ATMOSPHERIC PERSPECTIVE See PERSPECTIVE.

ATTRIBUTE

An object traditionally used by artists to identify a person, office, or concept. Just as sitters are sometimes depicted with the tools of their trade in portraits, mythological and allegorical figures as well as saints are often identifiable by symbols long associated with their powers, dominions, or martyrdoms. In order to ensure comprehension, the complex language of attributes has been somewhat standardized in manuals compiled and printed beginning in the sixteenth century.

ATTRIBUTION

The informed assignment of a painting of uncertain authorship to a particular artist, to his or her followers, or to an unknown artist. (In the latter case, the so-called school of a painting is usually specified, such as "Venetian, sixteenth century.") Employing CONNOISSEURSHIP, art historians and critics make attributions by comparing stylistic traits in unattributed paintings to those found in works securely assigned to an individual or characteristic of a certain place at a certain time. External evidence from contemporary descriptions, contracts, and inventories can also be employed. Even with well-known artists, attribution can be highly subjective. Opinions as to the authenticity of a painting can also be controversial because of their effect on the work's monetary value.

The terminology used in connection with attribution is hardly exact but generally follows a pattern of diminishing contact with the artist. A painting is called *autograph* when it is thought to be entirely the work of an artist. *Attributed to* signifies less certainty that the work is wholly by the individual. Virtually synonymous, *ascribed to* sometimes implies a slightly greater degree of doubt or an old attribution used for the sake of convenience. *Studio of* or *workshop of* is used with paintings made by an unknown assistant or assistants in the artist's shop, perhaps under the artist's direct supervision. *Circle of* and *style of* designate an unknown hand influenced by the artist and working in about the same period, while *follower of* and *manner of* usually indicate a later date. *After* generally indicates a copy of a known work made at any date. See also ORIGINAL.

ATTRIBUTE

Bartolomeo Vivarini
(Italian, ca. 1432–1499),
Saint James the Greater,
1490. Tempera on panel,
144 × 56 cm (56¾ ×
22 in.). Central panel
from a polyptych.
JPGM, 71.PB.30.

The attributes of Saint
James the Greater are
the pilgrim's staff and
the scallop shell, which
alludes to the distinctive
badge worn by pilgrims
to the saint's shrine at
Santiago de Compostela
in Spain.

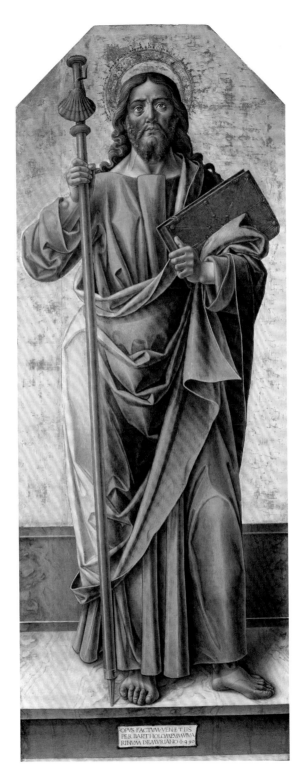

AU PREMIER COUP See ALLA PRIMA.

AUTOGRAPH See ATTRIBUTION.

AUTOGRAPH COPY See ORIGINAL.

AUTOGRAPH REPLICA See ORIGINAL.

BARBE

A buildup of paint at the edge of a hard surface. The barbe is usually at the vertical and/or horizontal edges of a PANEL painting where the paint, applied with a BRUSH, has accumulated due to the brush hitting the edge of a temporary or engaged FRAME in which the panel was held.

BITUMEN

Sometimes referred to as *asphaltum*; a naturally occurring tarlike substance that produces a deep, warm, brown-black color. It has been used since ancient times and can be found in the GROUNDS and paint films of European and American paintings of many periods, although its usage is most commonly associated with English painters of the eighteenth century.

Bitumen is mixed with linseed OIL in order to create a painting material. Unfortunately, bituminous paint films rarely dry properly; when bitumen is used as an UNDERPAINT, a faster-drying paint applied on top of the slower-drying bitumen will literally slide across the surface of the wet bituminous layer as it dries, resulting in the development of large shrinkage cracks (see CRAQUELURE). Paintings that contain bitumen are also easily damaged during cleaning (see CONSERVATION) as a result of the soft, soluble nature of the material.

BODYCOLOR

An opaque paint layer, as opposed to one that is transparent (such as transparent chromium-oxide green, called *viridian*). Bodycolors can be used as opaque MIDDLE TONES in creating the ILLUSION of form; shadows are added with transparent darker GLAZES, highlights created with opaque lighter SCUMBLES. When associated with prints, drawings, or WATERCOLORS, the term *bodycolor* refers to water-based, opaque paint MEDIA such as GOUACHE and TEMPERA. (See illustration for SQUARING.)

BOLE

A clay material that is used as the preparatory layer for the application of very thin layers of metal leaf, most commonly gold or silver. Bole is prepared by mixing colored clay with a water-based adhesive (such as rabbit-skin glue). Although traditional boles are usually dark red in color, many variations can be found, ranging from white to light yellow to deep violet. Because metal leaf is very thin, the color of the bole has a substantial effect on the appearance of the GILDING. In pictures that have suffered from cracks or ABRASIONS in gilt areas, the bole can often be seen in areas where the metal leaf is missing.

In water gilding, the bole mixture is applied to the area to be gilded and allowed to dry. A smooth piece of agate may be used to burnish the surface of the colored clay. The bole is then re-wetted in order to activate the adhesive, and the metal leaf is applied. The bole layer may also be referred to as the *poliment* (a term used to describe a preparation layer for GILDING; see illustration on p. 36).

BOZZETTO See OIL SKETCH.

BRUSH

The basic tool used to apply not only paint but VARNISHES and metal leaf to a surface. Historically, a brush was occasionally known, rather confusingly, as a pencil. Brushes are made from a wide variety of materials and come in a nearly infinite array of shapes and sizes. Cennino Cennini, writing in the fifteenth century, described delicate brushes made from the fur of a miniver (or ermine) and mounted on quill handles, as well as larger brushes made from hog hairs and attached to wooden sticks. In the nineteenth century, metal ferrules were introduced as a means of holding the brush hairs together. The size and shape of the ferrule were dictated by the desired size (wide or narrow) and shape (flat or round) of the brush. In modern times, brushes of the highest quality are most frequently made with red sable hair. Coarser animal hairs are still used to make bristle brushes, and a number of synthetic fibers have been introduced in the twentieth century.

BRUSHWORK

Textures and impressions within a painting created by the workings of the artist's BRUSH. Because it is a direct reflection of the pressure and movement of the artist's hand across the surface of the painting, brushwork is one of the most intimate links that we, as viewers, have with the artist's mind at work. Its specific nature and qualities therefore can serve almost as a SIGNATURE (see ATTRIBUTION).

Brushwork can be as varied as the types of brushes used to create a painting. Characterizations of brushstrokes include such divergent descriptive terms as *broad* and *fluid* (sometimes referred to as *painterly*), *tight* and *controlled*, and *thick* and *textured* (see also IMPASTO). Brushwork may not even be immediately apparent: in early

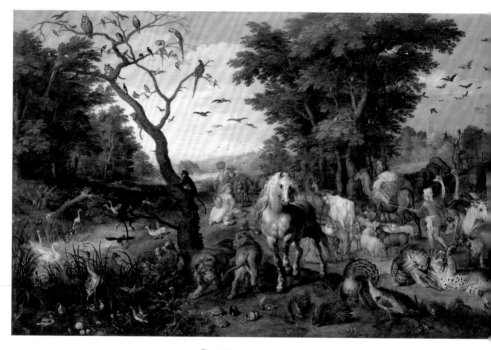

BRUSHWORK

Jan Brueghel the Elder (Flemish, 1568–1625), *The Entry of the Animals into Noah's Ark*, 1613.
Oil on panel, 54.6 × 83.8 cm (21½ × 33 in.). JPGM, 92.PB.82.

Italian EGG-TEMPERA paintings, for example, the fact that the image is composed of a pattern of overlapping short brushstrokes becomes apparent only on very close inspection.

The term *stippling* refers to the technique of making repeated applications of paint by holding a stiff brush directly perpendicular to the surface of the painting.

CABINET PICTURE

A small painting suitable for display in a specialized private collection. Characterized by fine execution and sometimes a precious SUPPORT, such as COPPER, a cabinet picture invites close study. Dutch and Flemish painters working around 1600 produced exquisite small works that were avidly collected primarily by private individuals for display and scrutiny in a small room of an intimate scale known as a *cabinet*. The phenomenon of the collector's cabinet or *Kunstkammer*, a carefully selected assemblage of rare objects of art and nature, itself became the subject of paintings in the 1600s.

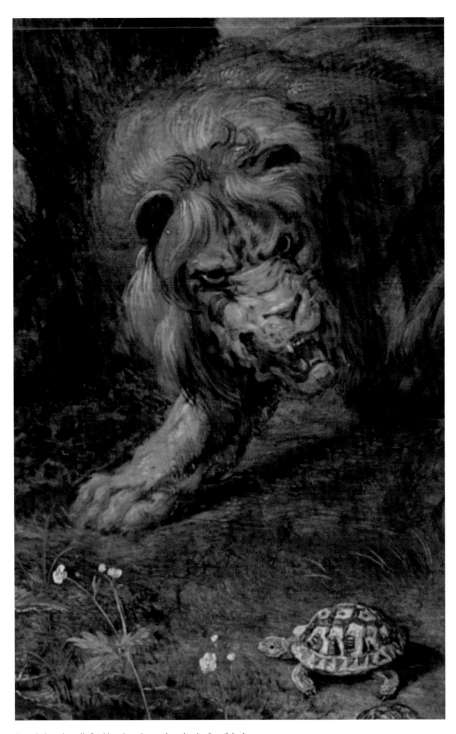

Brueghel used small, fluid brushstrokes to describe the fur of the lions.

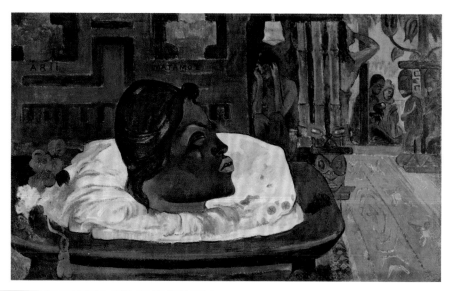

CANVAS

Paul Gauguin (French, 1848–1903), *Arii Matamoe (The Royal End)*, 1892.
Oil on coarse fabric, 47.9 × 74.9 cm (18⅞ × 29½ in.). JPGM, 2008.5.

CANVAS

A piece of textile fabric woven from flax, hemp, or cotton fibers. However, the word has generally come to refer to any piece of fabric used as a SUPPORT for painting.

Use of canvas supports can be traced back to ancient times, but our traditional understanding of its development stems from the practice in early Italian Renaissance painting of gluing a piece of linen to a wooden PANEL prior to application of a GESSO GROUND. Variations on this practice included stretching the fabric loosely across the panel support and, eventually, supporting the canvas only at the edges with a frame of wood (called a strainer). Later, canvases were attached at the edges to an expandable frame of wood called a STRETCHER.

Early canvas paintings were also developed for use as banners or processional pieces. The light fabric support provided a practical alternative to heavy and cumbersome large wooden panels. Large canvas paintings could also be used in place of more costly tapestries in decorative schemes.

Canvas can range in texture and weight from very fine (similar to handkerchief linen) to very coarse (such as burlap). The character and pattern of the canvas are usually visible on the surface of the painting. Although most canvas paintings are executed on a plain weave fabric, unusual patterns (such as herringbone or twill) can also be found. Some artists have used fabrics from domestic settings—including handkerchiefs, tablecloths, and mattress ticking—to exploit textile patterns, or in the absence of standard artists' materials.

Gauguin used a textile woven from jute fiber as a canvas for this painting, executed while he was in Tahiti.

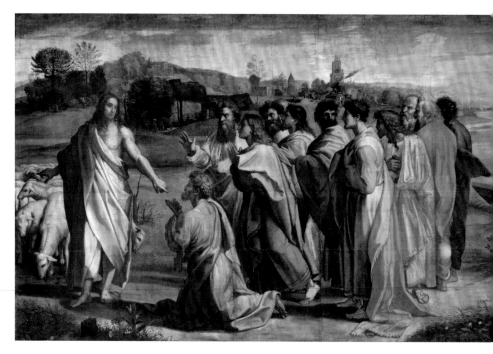

CARTOON

Raphael (Raffaello Sanzio [Italian, 1483–1520]), *Cartoon for the Tapestry of the Charge to Peter*, ca. 1515/16. Gouache on paper, 343 × 532 cm (135 × 209 ½ in.). The Victoria and Albert Museum, London/Art Resource, NY.

CARTOON

A full-scale drawing or painting used in the transfer of a design to an easel painting, FRESCO, tapestry, stained glass, or other work, usually of large size. The term derives from *cartone*, the Italian word for the heavy paper on which cartoons were made. They were usually executed with chalk or charcoal and sometimes were fully colored in WATERCOLOR, GOAUCHE, TEMPERA, or OIL.

For frescoes and tapestries, cartoons were cut into sections. For frescoes, a portion of the design was laid on the wet plaster, and each day's work (*giornata*) was transferred by POUNCING or by INCISING the design through the cartoon with a stylus. The word *cartoon* gained its contemporary meaning as a humorous drawing or parody when the designs for the murals in the British Houses of Parliament were satirized in *Punch* in 1843.

CASEIN

A MEDIUM made from the curd of soured skim milk. Although casein powder mixed with limewater has been used as a binder for PIGMENTS since ancient times, only scattered references to the use of casein in old master paintings can be found. During the nineteenth century, casein colors gained some popularity and were commercially manufactured. The surface of a casein painting has a matte sheen, casein paint layers can be burnished so as to take on a slightly shiny surface that imitates an EGG-TEMPERA surface.

Casein is considered to be a difficult medium that presents problems in handling and correction (primarily because of its quick-drying nature); it also forms an extremely brittle film that does not age well.

CASSONE PAINTING

A painted PANEL inset in a large Italian chest, but today often displayed detached and framed like an easel painting. Sometimes the biblical or mythological episodes depicted in these paintings celebrate marriage, but battle scenes were also produced in great numbers. Particularly popular in fifteenth-century Florence, this type of furniture decoration was usually executed by specialists who seldom produced paintings of high quality, but occasionally cassoni were painted by great artists.

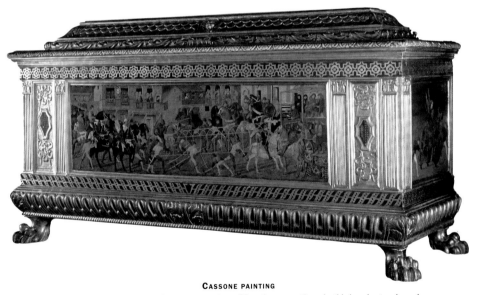

CASSONE PAINTING

Florentine school, *Cassone with a Tournament Scene*, fifteenth century. Carved, gilded, and painted wood.
Main panel: 38.1 × 130.2 cm (15 × 51¼ in.). NGL, 4906. © National Gallery. London.

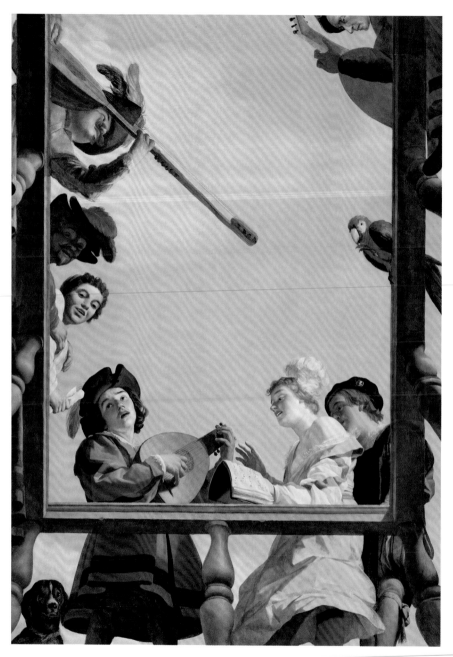

CEILING PAINTING
Gerrit van Honthorst (Dutch, 1590–1656), *Musical Group on a Balcony*, 1622.
Oil on panel, 309 × 114 cm (121⅝ × 44⅞ in.). JPGM, 70.PB.34.

CEILING PAINTING

A scene painted on or installed as the overhead surface of a room or gallery and intended for viewing from below. By suggesting an extension of three-dimensional

space upward, an artist created the illusion of architectural structure or open sky. This highly specialized form of painting requires a sophisticated use of PERSPECTIVE and a knowledge of ILLUSION and TROMPE L'OEIL. The techniques of SOTTO IN SÙ and QUADRATURA are closely related forms of illusionistic painting. Brought to great sophistication in Renaissance and Baroque Italy, ceiling paintings were relatively rare in Northern Europe.

Honthorst's illusionistic ceiling (seen here in its installation at the Getty Museum) is the earliest known work of its kind from Northern Europe. Photo: Jack Ross.

CHIAROSCURO

The conjoining of the Italian words *chiaro* (light) and *oscuro* (dark). Chiaroscuro describes the effects of light and shadow in painting, particularly when the contrast between the two is very pronounced. The term is most often associated with the lighting found in the paintings of Caravaggio and his followers, and of Rembrandt. This dramatic illumination is often characterized by a shaft of light like that produced by a spotlight, which results in strong highlights and sharply cast shadows. Compare SFUMATO.

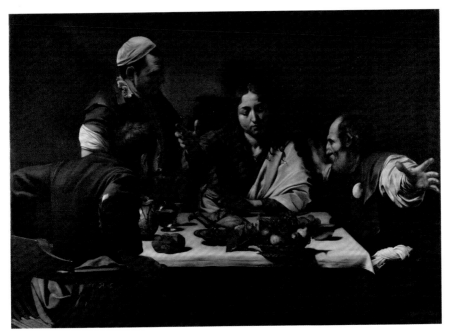

CHIAROSCURO
Michelangelo Merisi da Caravaggio (Italian, 1573–1610), *The Supper at Emmaus*, ca. 1600.
Oil on canvas, 141 × 196.2 cm (55½ × 77¼ in.). NGL, 172. © National Gallery, London.

CIRCLE OF See ATTRIBUTION.

COLLABORATION

The practice of two or more artists working together to produce a work of art. The term was coined in the nineteenth century to refer to joint labor, but not specifically artistic production. The process of painters working in cooperation on a common endeavor was a characteristic feature of Netherlandish painting of the late medieval, Renaissance, and Baroque periods. Encompassing many degrees and forms of shared labor, collaboration emerged from the traditional hierarchical WORKSHOP practice and especially the phenomenon in which painters began to specialize in particular genres during the sixteenth century. See also RESERVE.

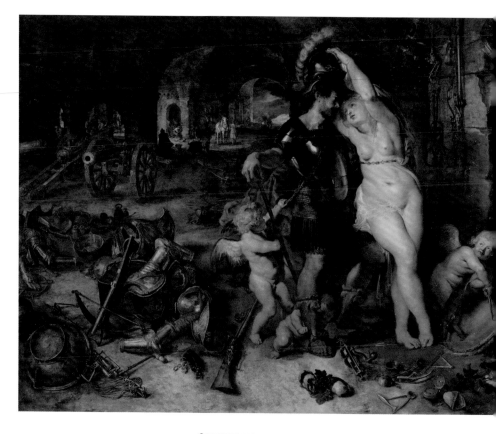

COLLABORATION

Peter Paul Rubens (Flemish, 1577–1640) and Jan Brueghel the Elder (Flemish, 1568–1625), *The Return from War: Mars Disarmed by Venus*, ca. 1610–12. Oil on panel, 125.5 × 160 cm (49⅜ × 63 in.). Acquired in honor of John Walsh, JPGM, 2000.68. Brueghel painted the setting and still life of weapons and other items, while his friend and colleague Rubens painted the figures in this work, which showcases each artist's specialty.

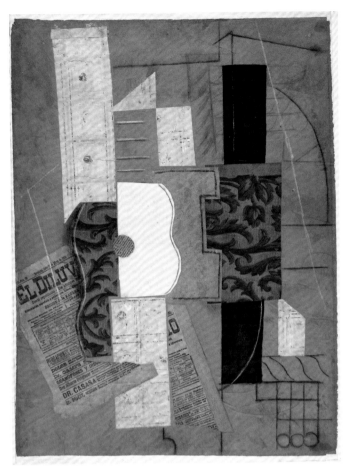

COLLAGE

A nontraditional assembly of materials and forms used to create an artwork. Materials such as paint, photographs, found objects, paper, tape, and/or textiles may be adhered to a SUPPORT to create a collage.

COLOR

White light (such as sunlight) contains all the different wavelengths of light that are seen as color; a prism can be used to separate white light into the familiar rainbow spectrum. Individual colors are perceived by the eye (and the mind) when specific wavelengths of light are reflected off a surface. A blue PIGMENT, for example, will

absorb all wavelengths of light except those in the blue range, which are reflected for us to see.

Colors are characterized by three attributes: *hue* or *tint* (which refers to the common name of the color, such as red or green), *value* or *tone* (which defines the relative lightness or darkness of the color, corresponding to a gray scale that ranges from white to black), and *intensity* (which describes the degree of saturation of the color: a pale blue is considered to be less intense than a deep, rich blue, for example).

The synonymous terms *half-tone* and *middle tone* are used to describe a color that falls somewhere between the lightest, least intense, and the darkest, most saturated appearance of a particular hue. In painting, half-tones are usually found in the part of the form (as in a piece of drapery or a flesh tone) that lies between the highlight and shadow. In this way, color is used to create the ILLUSION of three-dimensional form.

Artists become familiar very early in their training with the basic color-mixing rules. The primary colors are red, yellow, and blue. The secondary colors of orange, green, and violet are achieved by mixing the primary colors in various combinations (yellow mixed with blue produces green, for example). Warm colors contain more red tones and cool colors contain more blue tones. Complementary colors are considered to be in extreme contrast to one another (such as red and green, which, when placed side by side, intensify each other's appearance and, when mixed together, produce gray). The illusion of iridescent shot fabrics (which appear in many paintings) stems from the use of complementary colors in the highlights and shadows of a drapery.

Color theory has played an important role in the history of art. Most color theories represent attempts to classify or systematize the way in which the eye sees color and provide the artist or viewer with a series of aesthetic guidelines.

COLOR FIELD PAINTING

An abstract style of painting where large areas of color make up the composition. This style of painting emerged in the 1950s.

CONNOISSEURSHIP

The method of ATTRIBUTION that uses visual evidence alone to identify the specific author of a work of art or its time and place of execution. With an in-depth knowledge of period and individual styles, the connoisseur (from the French, meaning "one who knows") evaluates a work of unknown authorship by comparing its visual characteristics with those of other works known to them. Equally important is the ability, formed through years of study of original works, to discern the quality or the relative aesthetic merits of a given object.

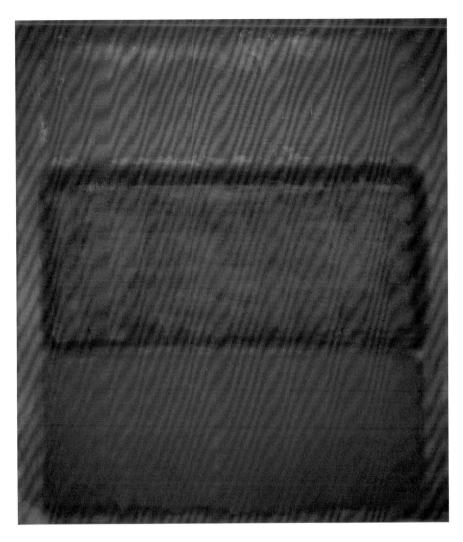

COLOR FIELD PAINTING

Mark Rothko (American, 1903–1970), *No. 301 (Reds and Violet over Red/Red and Blue over Red [Red and Blue over Red)]*, 1959. Oil on canvas, 236.5 × 205.7 cm (93 ⅛ × 81 in.). The Museum of Contemporary Art, Los Angeles, The Panza Collection, 88.15. © 1998 Kate Rothko Prizel and Christopher Rothko/Artists Rights Society (ARS), New York.

CONSERVATION

The preservation and restoration of works of art. Paintings are composed of inherently unstable materials that undergo complex changes as they age and interact with their environment. Changes occur as the result of natural aging (such as the fading of FUGITIVE PIGMENTS or the development of CRAQUELURE) or from interference from a host of outside factors (including such damage as tears and holes). Any change in the appearance of the materials used in a painting alters the appearance of the entire work of art and, ultimately, affects our perception of both the artist's and the work's meaning and intent. During the processes of preservation and restoration, conservators must be able to combine their knowledge of painting materials with their deeper understanding of the particular work in order to present and preserve for the future a work of art that still has significance as a unified whole.

Problems within paintings that require repair and restoration are diverse and complex. VARNISH coatings discolor with time and can be removed or replaced; structural weaknesses develop in SUPPORTS, which can be stabilized and reinforced; and lost or damaged areas in the painting can be reconstructed through RETOUCHING. Such treatments are supported by the ethical demands of modern conservation, which dictate that any alterations or additions to a painting must be completely reversible.

Preservation of paintings has been greatly enhanced by improved methods of climate control. Stable levels of temperature and humidity can be provided, and light sources can be filtered and controlled in order to create ideal environments. Such controls, linked with the use of increasingly stable restoration materials, can do much to enhance the preservation of paintings.

COPPER

Although not as common as wood or CANVAS, a SUPPORT for painting. Copper could be hammered by hand into a thin sheet; this method produced a characteristically uneven surface, which was preferred by some artists. Techniques for rolling the metal into thin plates were introduced in the middle of the sixteenth century. During the sixteenth century, copper became a popular support in Europe for smaller paintings. The natural deep reddish brown of a copper plate was often favored by artists for use as a GROUND color.

Paintings executed on copper tend to have an enamel-like surface as a result of the smoothness of the support. Copper does not respond as quickly as wood or canvas to changes in temperature and humidity, and, as a result, copper paintings are often beautifully preserved.

COPY See ORIGINAL.

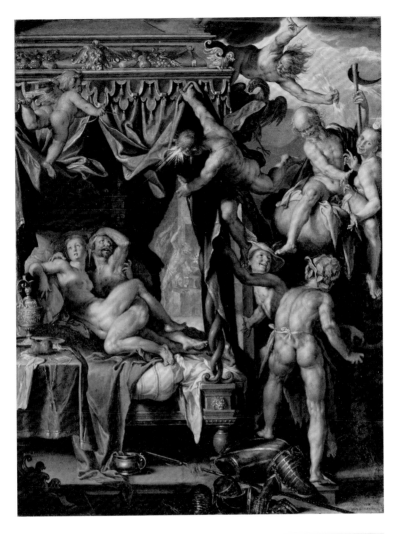

COPPER

Joachim Anthonisz. Wtewael
(Dutch, 1566–1638), *Mars
and Venus Surprised by
Vulcan*, ca. 1606–10.
Oil on copper, 20.3 × 15.5
cm (8 × 6⅛ in.). JPGM,
83.PC.274.

The copper support (seen
here from the back) gives
Wtewael's rich palette a
jewel-like quality.

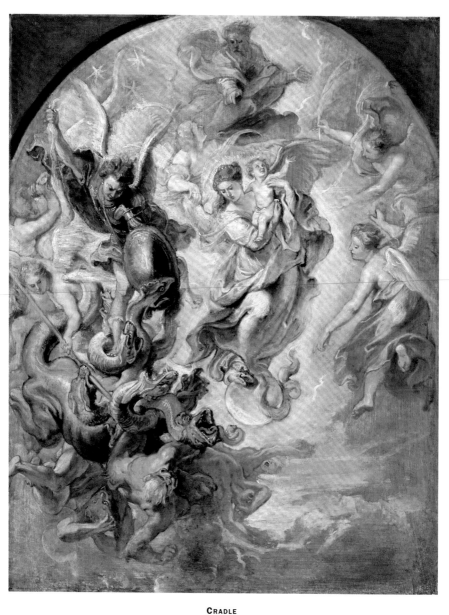

CRADLE

Peter Paul Rubens (Flemish, 1577–1640), *The Virgin as the Woman of the Apocalypse*, 1623–24.
Oil on panel, 64.5 × 49.8 cm (25⅜ × 19⅝ in.). JPGM, 85.PB.146.

CRADLE

A wooden structure attached to the reverse of a PANEL painting, which, in theory, is designed to prevent warping or splitting of the SUPPORT with changes in humidity.

The concept of cradling may have developed from the practice of early Italian panelmakers of placing wooden supporting battens in shallow channeled grooves

A cradle was applied to the back of Rubens's painting during the nineteenth century.

on the reverse of panels, running perpendicularly to the grain of the wood. The modern cradle, which was developed during the nineteenth century, is a more complex assembly of interlocking supports: strips of wood running parallel to the grain are glued to the panel in a fixed position; wooden strips aligned perpendicularly to the grain are held in place by the fixed bars but are free to move with the natural expansion and contraction of the panel as it responds to changes in temperature and humidity. Prior to application of a cradle, the reverse of the original panel is often planed to create an even surface.

Unfortunately, cradles can become locked in place over time as the strips of wood in the cradle expand and may actually promote the kinds of problems (such as splits) that they were designed to prevent. The massive nature of many cradles can also significantly alter the basic character of a painting: if the original panel is thinned to an excessive degree, the impression of the cradle can be transferred to the surface of the painting, creating an unsightly washboard effect. Since cradles can cause damage, today they are often removed from panel paintings.

In recent years, cradling has fallen out of use in favor of less invasive techniques for treating structural problems in wooden supports.

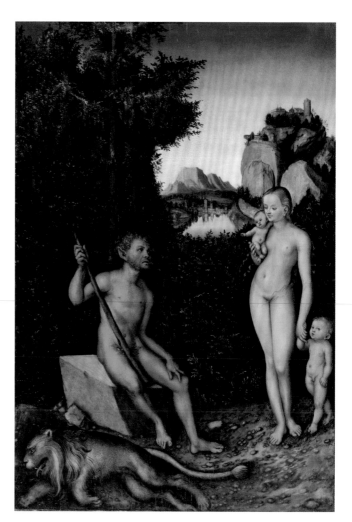

CRAQUELURE

A pattern of cracks that develops on the surface of a painting as a result of the natural drying and aging of the whole structure of the painting and influenced by the type of environmental conditions to which the painting has been exposed.

The use of different types of paint MEDIA and painting SUPPORTS will result in varying types of craquelure. TEMPERA paintings, for example, will develop a characteristically delicate craquelure, which in some cases may be so fine as to be nearly invisible to the naked eye. OIL paintings, on the other hand, tend to develop a more prominent network of *drying cracks*; the pattern will vary according to the type of support used. If significant amounts of resins or other complex materials are mixed with the paint, large, disfiguring drying cracks may develop, imparting a texture to the surface of the painting that resembles reptile skin (hence the term *alligator cracks*). A circular pattern of *impact cracks* can develop in a canvas painting as the result of a foreign object striking the surface or the reverse of the painting.

Craquelure is considered a natural and, to some extent, desirable phenomenon. Drying cracks do not necessarily indicate that the paint has loosened from the support. Although the visual prominence of excessive crackle patterns can be minimized with RETOUCHING, the presence of most craquelure should simply be accepted.

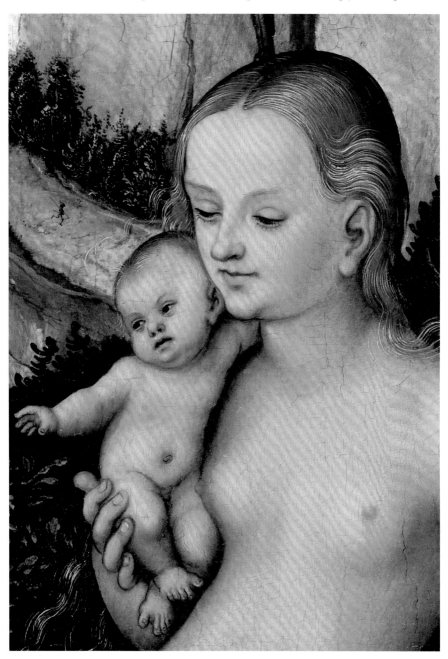

The fine pattern of rectangular cracks is particularly visible in light-colored areas, such as the flesh.

CROSS SECTION

A tiny sample taken from a painting and mounted in a resin, which cures to become a solid block that may then be ground so that a cross section of the paint layers is produced. The cross section represents the layer structure of the painting in the area sampled and may include the GROUND layer, preparation layer(s), UNDERDRAWING materials, paint layer(s), and surface coating(s) (VARNISHES).

The sample must be viewed under high magnification since it is so small. The cross section is often viewed under both normal and ULTRAVIOLET lighting condi-

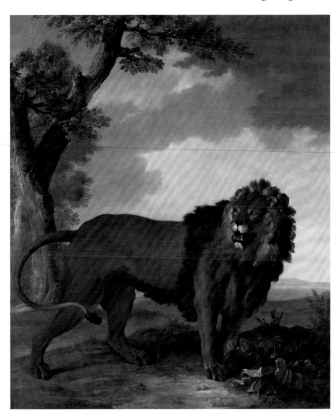

CROSS SECTION
Cross section seen in reflected light (top) and in ultraviolet light (bottom) from Jean-Baptiste Oudry (French, 1686–1755), *Lion*, 1752. Oil on canvas, 307.3 × 257.8 cm (121 × 101½ in.). Schwerin, Staatliches Museen.

This sample, magnified 250 times, illustrates, from the top: a layer of dirt, a layer of varnish, two blue paint layers for the sky over a yellow-colored preparation layer, and a red-colored preparation layer.

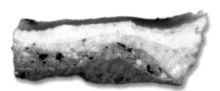

When the sample is viewed in ultraviolet light, the varnish layer and lead white pigments are distinguished by a bright fluorescence.

tions since some materials have fluorescent properties that help characterize them. For example, varnish layers made from natural resins often fluoresce as bright white, blue, or yellow under ultraviolet light.

CUSPING

A pattern of arc shapes created in woven fabric SUPPORTS due to the points of tension holding the CANVAS to a secondary support such as a STRETCHER or strainer. Cusping is also described as *scalloping*. Cusping patterns can develop along all edges of a canvas and can often be seen through paint layers and are made visible in X-RADIOGRAPHS.

DEAD COLORING

A monochrome or muted color used in the preparation of a painting to plan and build up certain areas before the upper colored layers are added. See UNDERPAINTING.

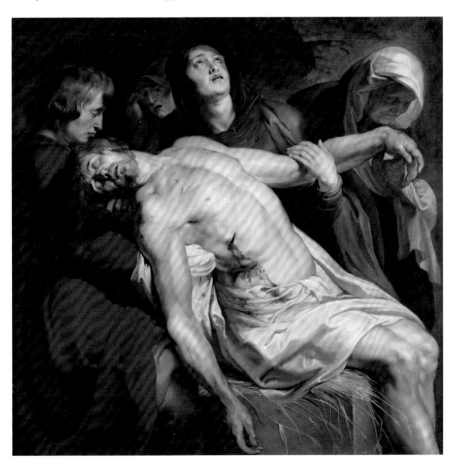

DEAD COLORING
Peter Paul Rubens (Flemish, 1577–1640), *The Entombment*, ca. 1612.
Oil on canvas, 131 × 130.2 cm (51⅝ × 51¼ in.). JPGM, 93.PA.9.
Rubens used dead coloring to create the cool gray tones of Christ's arms and legs.

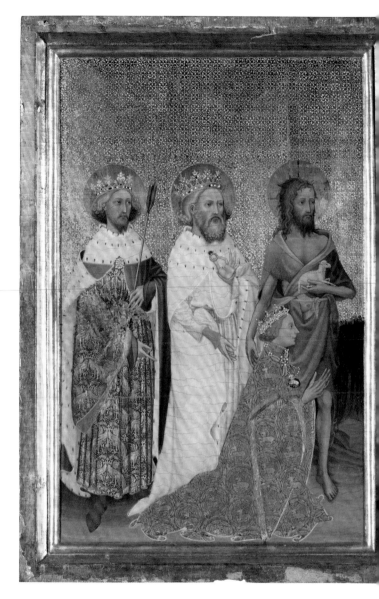

DIPTYCH

A picture comprising two PANELS, or leaves, usually hinged together so that they can be closed like a book. Diptychs were most often made on a small scale for portable devotional use but could also be decorated with portraits. In one typical arrangement, one panel would contain a portrait of the owner praying to the Virgin and/or Christ, who would be represented on the other panel. The backs of the panels were also decorated, sometimes imitating precious stones or bearing the coat of arms of the owner. See also TRIPTYCH and POLYPTYCH.

DIRECT PAINTING See ALLA PRIMA.

DISTEMPER

A water-based paint MEDIUM made from animal glue. Distemper has a characteristic dry appearance since it was often applied directly to CANVAS SUPPORTS that did not have a GROUND or preparation layer (TÜCHLEIN painting). The medium dries quickly. Distemper paintings were not usually varnished, as VARNISH would significantly alter the appearance of the colors. Many distemper paintings do not survive in good condition because they have been misinterpreted and treated as OIL paintings.

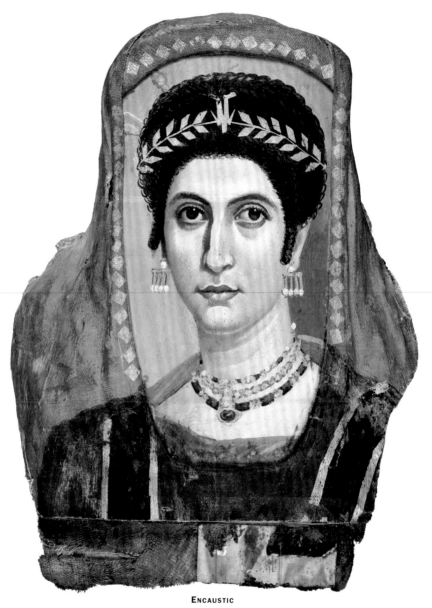

ENCAUSTIC
Egyptian (Fayum district), *Mummy Portrait of a Woman*, ca. A.D. 100–110. Encaustic and gold leaf on panel,
33.6 × 17.2 cm (13¼ × 6¾ in.). JPGM, 81.AP.42.

EGG TEMPERA See TEMPERA.

EMULSION

A mixture of two materials that do not naturally mix (such as OIL and water). In
order to create a paint MEDIUM, an emulsifying agent is introduced to a mixture of
oil (or resin) and water, thus allowing tiny droplets of the oil material to remain sus-

pended in the water. When the water evaporates, the oil material left behind forms the now-non-water-soluble film of paint.

Egg yolks are naturally occurring emulsions. Emulsions of egg and oil may have been used as painting media as early as the sixteenth century. In the twentieth century, synthetic polymer emulsions of man-made resins and water have been introduced as alternatives to oil paints. See also ACRYLIC.

ENCAUSTIC

A wax-based paint whose term derives from the Greek word *enkaustikos*, meaning "burning in." Encaustic paintings are created by mixing PIGMENT with molten wax (such as beeswax) and applying the mixture to a SUPPORT while it is still hot. After the colors have been completely applied, the entire picture is heated slightly in order to fuse the paint layers together. When the painting is cool or at room temperature, the paint is solid.

Encaustic is most commonly associated with Egyptian portraits on mummy cases of the second to fourth century A.D.; these are known as Fayum portraits because of their common occurrence in the Fayum district of Upper Egypt. The extreme stability of the encaustic MEDIUM has allowed Fayum portraits to remain exceptionally well preserved, possessing an astonishing clarity.

Encaustic was rarely used again as a paint medium until the early twentieth century, when some artists developed an interest in the fact that encaustic could be used to create thick, vibrant IMPASTO with an opaque, matte surface (as opposed to the glossy surfaces of OIL paints).

ENGAGED FRAME See FRAME.

FAKES AND FORGERIES

Objects that simulate the appearance of genuine works of art but were made with a deliberate intent to deceive. The creation of a forgery is usually motivated by financial gain, and as the value of particular works of art increases, so does the incentive for forgers.

When creating a painting that purports to be a work from an earlier period, a forger will often unwittingly produce stylistic or technical anomalies from his or her own time. Conversely, when creating a *pastiche*, a painter intentionally imitates the work of a particular artist or artistic style by copying a number of elements from a variety of original paintings and recombining them in a single work. Unlike a forgery, a pastiche is not necessarily intended to deceive. Today, it seems unlikely that a forger could produce a work of art without some sort of technical anomaly.

FECIT See SIGNATURE.

FOLLOWER OF See ATTRIBUTION.

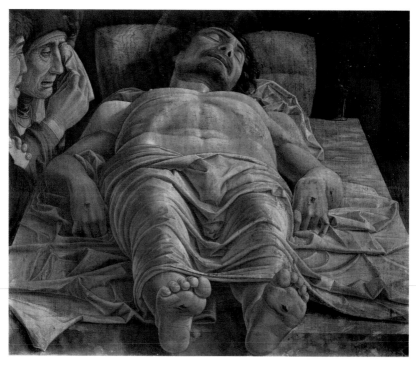

FORESHORTENING

The technique of depicting an object or figure in PERSPECTIVE so that it appears to recede. Forms lying at an angle to the PICTURE PLANE are proportionately compressed to produce the ILLUSION of their extension in space. This term is applied to individual things or their parts, as opposed to *perspective*, which refers to the overall construction of space. See also SOTTO IN SÙ.

FRAME

A border around a picture added to enhance its appearance by isolating it from its surroundings or by linking it to the decor. Decorative borders are quite ancient, but frames as we know them originally served a protective or structural function around religious images that were handled or set in large architectural ALTARPIECES. Frames are most often made of wood but may be painted in TROMPE L'OEIL at the edge of CANVASES or around FRESCOES. In the nineteenth century, molded plaster frames became common and were usually GILDED like their carved wood counterparts.

An *engaged frame*, or *integral frame*, is fashioned from the same piece of wood as a PANEL painting and remains an integral part of it. Created by the painter or to the painter's specifications, such engaged frames sometimes use ILLUSIONISM to

connect the frame and the image or carry an inscription related to the meaning of the work.

Except for engaged frames, it is often difficult to establish that a frame is original to a painting, even if it is contemporary, unless there is specific documentation. Paintings have often been reframed according to the individual tastes of owners, usually in more contemporary styles.

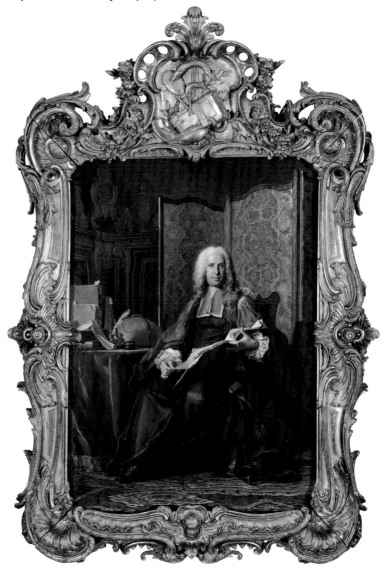

FRAME

Maurice-Quentin de La Tour (French, 1704–1788), *Gabriel Bernard de Rieux, président de la deuxième chambre des enquêtes du Parlement de Paris*, 1739–41. Pastel and gouache on paper mounted on canvas, 317.5 × 223.5 × 29.2 cm (125 × 88 × 11½ in.) (framed dimensions). JPGM, 94.PC.39.
This elaborate carved and gilt frame was designed specifically for de La Tour's life-size portrait.

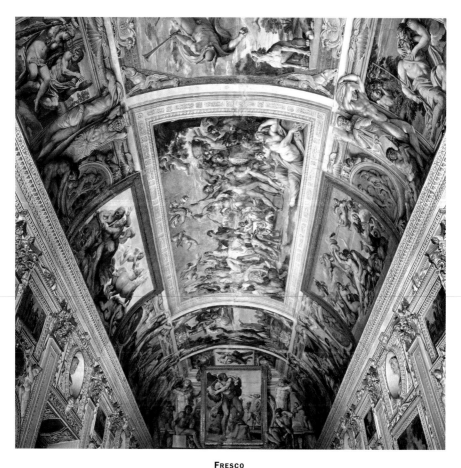

FRESCO

The technique of wall painting in which PIGMENTS mixed in water (or limewater) are applied directly onto freshly laid lime plaster; from the Italian word for "fresh." This method, called *buon fresco*, or *true fresco*, is extraordinarily permanent in dry climates because the colors penetrate into the plaster and become an integral part of the wall as it dries. Thus, the technique was favored for all major wall paintings in central Italy but was little used in Northern Europe, where damp would quickly cause the plaster to crumble. Fresco is particularly valued for the bright luminosity of its colors, which retain their original brilliance to an exceptional degree.

The wall is prepared by laying on a rough coat of lime and sand called the *arriccio*. Then a coat of fine plaster called the *intonaco* is laid on and the paint applied. Only enough intonaco for one day's work is prepared because plaster dries overnight. Each section of intonaco is called a *giornata* (day), and it is possible to determine the time taken to complete the fresco by counting these sections. Fresco is a

demanding technique because of the speed of execution required and because it is virtually impossible to correct work without removing the plaster and starting again. Only an experienced fresco painter can know the final effect, because wet colors look quite different after they have dried.

Early artists often painted their designs onto the arriccio with *sinopia*, a reddish brown chalk mixed in limewater. This type of drawing has been recovered from frescoes detached from their original wall for reasons of preservation. Later, artists used CARTOONS to transfer their designs to the intonaco by POUNCING or INCISING. *Fresco secco*, or painting onto dry (*secco*) plaster, approximates the effect of true fresco but is susceptible to flaking. Sometimes whole works were painted in this technique, but it was also commonly used by painters RETOUCHING true frescoes; unfortunately, these details in fresco secco are often lost owing to their fragility. *Mezzo fresco*, or *half-fresco*, involved painting onto partially dried plaster, a technique common from the mid-sixteenth century. By the end of the eighteenth century, the use of fresco was more the exception than the rule. The technique was revived (and revised) in the nineteenth century, particularly by the Viennese group known as the Nazarenes; the greatest twentieth-century exponents were Mexican muralists.

FUGITIVE PIGMENT

A PIGMENT that is particularly susceptible to fading over time. The fading process is actually a chemical change initiated by exposure to light. Pigments made from organic dyes (from insect and plant sources) are often fugitive in nature; the original color may be quite intense but will fade quickly. In Northern European still-life paintings of the seventeenth century, for example, an intense yellow pigment (known as *yellow lake*) was commonly mixed with a blue pigment in order to create the visual effect of green leaves. Over time, the yellow lake has faded, resulting in the illusion of blue leaves. The edges of paintings that lie under a frame and are not exposed will often have passages of paint that are not as faded due to their limited exposure to light.

FUGITIVE PIGMENT
Jacob Pynacker (Dutch, 1622–1673), *Landscape with Sportsmen and Game*, ca. 1665. Oil on canvas, 195 × 130 cm (51 × 76½ in.). London, Dulwich Picture Gallery, DPG18429. By permission of the Trustees of Dulwich Picture Gallery.

The blue appearance of the leaves in the foreground of this painting may have resulted from the artist's use of a yellow lake pigment that subsequently faded.

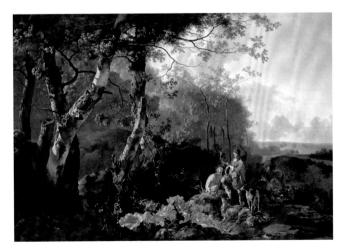

Genre Painting

Derived from the French word meaning "kind" or type," a category of subject, such as STILL LIFE. Genre scenes are depictions of the people and places of everyday life, such as markets, taverns, elegant parties, prostitutes, and middle-class families. Although not confined to Northern schools, genre subjects were popularized and treated with great ingenuity by seventeenth-century Dutch and Flemish painters.

Gesso

In the strictest sense, the Italian word *gesso* refers to a mixture of calcium sulphate (a white powder commonly known as gypsum) and rabbit-skin glue that is applied in liquid form as a primer to the surface of a painting SUPPORT. In broader usage, the term has come to refer to many types of similar white preparatory layers, including those made from chalk (calcium carbonate), as well as modern synthetic adhesives.

The gesso layer smoothes out the irregularities in the support; it is usually applied in many thin layers and sanded, scraped, and polished between applications. The final smooth surface provides an optimum base for painting in a variety of MEDIA. See also GROUND.

Gilding

The technique of affixing very thin sheets of metal, called *leaf*, to a surface. For the backgrounds of religious PANEL paintings as well as for FRAMES, gold leaf was most often used, but artists and framemakers have also employed silver, tin, aluminum, and other metals. The oldest and most common method is *water gilding*, in which the surface is prepared with a coating of BOLE, a mixture of red clay and a water-

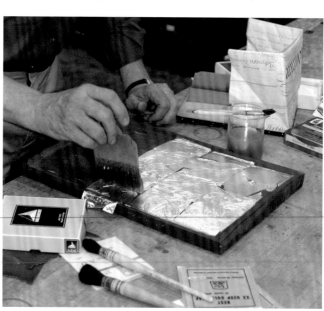

GILDING
Sheets of gold leaf are applied over a red-colored bole using a gilder's brush.
Photo: Tiarna Doherty.

based binder. Once set, the bole is wetted, reactivating the binder, and the leaf adheres to it as soon as it is placed in proximity. When the whole surface is covered, the leaf can be burnished to a brilliant metallic finish with polished mineral or bone. *Mordant gilding*, the other principal method, is achieved by applying an adhesive (mordant) to any surface. When it is dry enough to be sufficiently tacky, the leaf is laid on. This method differs from water gilding principally in that it cannot be burnished. Mordant gilding was primarily used in painting to add linear decoration in metal to the painted surface, usually to imitate gold cloth or metallic embroidery on drapery. The adhesive could be applied selectively to the painted surface in any pattern desired and the leaf would stick only to those areas. Powdered gold mixed with a binder was later used to apply linear decoration. It is called *shell gold* because of the shells used as containers and in which it was mixed.

An example of gilding can be seen in the illustration accompanying TRIPTYCH. For another technique used to create gold cloth, see SGRAFFITO.

GLAZE

A thin, transparent layer of paint that is applied over an opaque layer of paint. Glazes may also be applied on top of one another as a means of creating a sense of depth and translucency. The quantity of paint MEDIUM is much greater than the

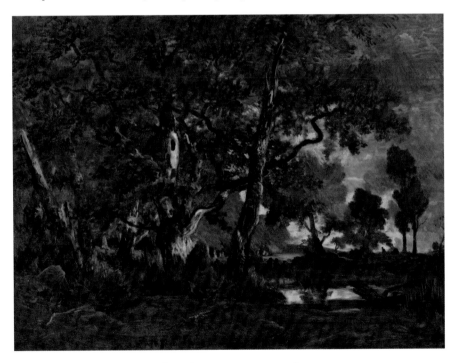

GLAZE (FIRST OF TWO ILLUSTRATIONS)
Théodore Rousseau (French, 1812–1867), *Forest of Fontainebleau, Cluster of Tall Trees Overlooking the Plain of Clair-Bois at the Edge of Bas-Bréau*, ca. 1849–55. Oil on canvas, 90 × 116 cm (35⁷⁄₁₆ × 45⁵⁄₈ in.). JPGM, 2007.13.
Rousseau layered dark brown glazes to establish the form and depth of the trees in the landscape.

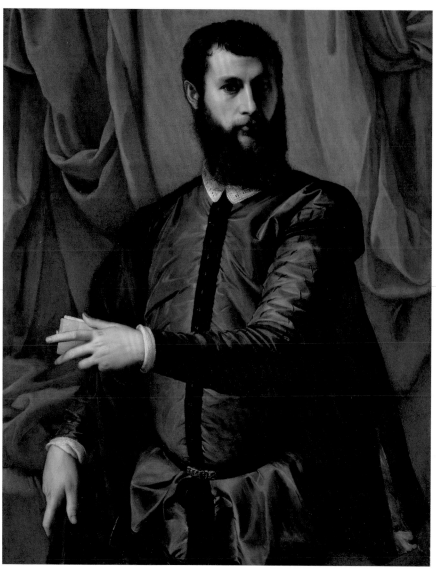

GLAZE (SECOND OF TWO ILLUSTRATIONS)

Francesco Salviati (Italian, 1510–1563), *Portrait of a Man*, ca. 1544–48.
Oil on panel, 108.9 × 86.3 cm (42⅞ × 34 in.). JPGM, 86.PB.476.
Glazes were used to create the deep shadows of the draperies in this portrait.

PIGMENT concentration in the paint used for a glaze, allowing light to pass through the layer and reflect off the paint layer below.

Although glazes can theoretically be made with all paint media, they are most commonly associated with OIL paintings. The rich, translucent nature of oil paint, which can be mixed with resins in order to facilitate the handling and transparency of the paint, lends itself to glazing techniques.

GLUE TEMPERA See TEMPERA.

GOUACHE

An opaque, matte, water-based paint made from gum arabic and a chalk-like filler. The term *gouache* can refer both to the paint MEDIUM and to the technique of using WATERCOLORS (which are also made from gum arabic) in an opaque fashion.

GRISAILLE

A French term for monochrome painting in shades of gray. The technique was used by painters in OIL SKETCHES to examine the overall balance between light and shade in a composition; to create UNDERPAINTING for a full-color painting; and to simulate sculpture or relief in independent compositions.

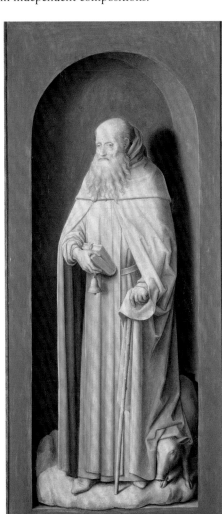

GRISAILLE
Hans Memling (German, act. 1465–d. 1491), *Saint Anthony Abbot,* ca. 1477 (exterior wing of *"The Donne Triptych"*). Oil on oak panel, 71 × 30.5 cm (28 × 12 in.). NGL, 6275. © National Gallery, London.

GROUND

The material applied to a SUPPORT in order to prepare it for painting. The term can be synonymous with the word *priming*. Different types of grounds can be loosely associated with different periods and schools of painting. Grounds were often colored with PIGMENTS and filler materials. In Northern European Renaissance painting, for example, grounds were traditionally made from mixtures of chalk (calcium carbonate) and rabbit-skin glue; in Italy during the same period, gypsum (calcium sulphate) was used. Venetian painters of the Renaissance favored red grounds; this practice eventually led to the wide use of a variety of ground colors, including dark earth tones, blacks, and even rich grays. Grounds of lead white and OIL were popular during the late eighteenth and nineteenth centuries.

Many artists have used double grounds, choosing to use two different colors in distinct layers that, in combination, produce a special effect.

HALF-TONE See COLOR.

HANDLING See BRUSHWORK.

HISTORY PAINTING

The portrayal of subjects derived from recognizable and significant past and contemporary events, as well as biblical, classical, and mythological subjects. Frequently derived from textual sources, the portrayal of historical subjects also combined skills used in other GENRES, including STILL LIFE and landscape painting. It was considered the highest and most respected category of painting among critics and within academies. History paintings are often narrative and may employ ALLEGORY to enhance and expand their content.

HORIZON LINE See PERSPECTIVE.

HUE See COLOR.

ICONOGRAPHY

The investigation and interpretation of subject matter in the visual arts. The term was first applied to any collection of portraits, most notably the portraits of famous contemporaries that was assembled by Anthony van Dyck (Flemish, 1599–1641). Today, the word is more commonly used to signify the branch of art history that studies the development of images and symbols, particularly as they relate to the meaning of an individual work in its historical context.

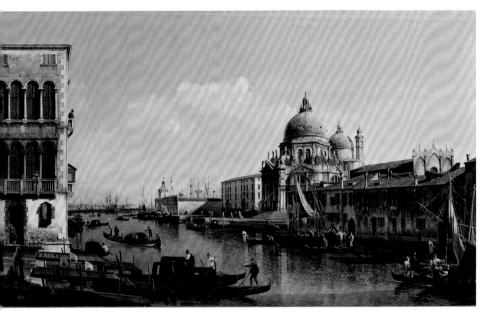

ILLUSIONISM

Bernardo Bellotto (Italian, 1722–1780), *View of the Grand Canal: Santa Maria della Salute and the Dogana from Campo Santa Maria Zobenigo*, ca. 1740. Oil on canvas, 131.5 × 231.8 cm (53¼ × 91¼ in.). JPGM, 91.PA.73. By extending and widening the canal and using a high vantage point, Bellotto created a dramatic ideal view of this Venetian landmark.

ILLUSIONISTIC/ILLUSIONISM

The creation of the appearance of reality in painting. Through the virtuoso depiction of nature and the manipulation of pictorial techniques such as PERSPECTIVE and FORESHORTENING, the illusionistic painter can convince the eye that what it sees is real. The French term *trompe l'oeil* (fools the eye) is often applied to a painting or a detail in a painting that is intended to deceive, delight, and astonish with its realism. There are a number of illusionistic tricks that the painter can employ, such as highly realistic flies painted on fruit, or dew on flowers. Artists who create murals to look like tapestries might add wrinkles and tears, and painters have often created illusionistic architecture to smooth the transition between actual and fictive reality. Scientific perspective was fully achieved in the fifteenth and sixteenth centuries, and it was rigorously applied in the illusionistic extension of whole rooms through painted architecture, a practice known as QUADRATURA. During the Baroque period, the great age of illusionism, painting was combined with real sculpture and architecture to create illusions of unprecedented believability, particularly in CEILING PAINTINGS bearing images of heaven.

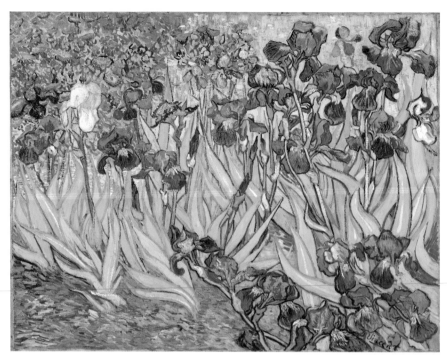

Vincent van Gogh (Dutch, 1853–1890), *Irises*, 1889. Oil on canvas, 71 × 93 cm (28 × 36⅝ in.). JPGM, 90.PA.20.

IMPASTO

The texture created in a paint surface by the movement of the BRUSH. *Impasto* usually implies thick, heavy BRUSHWORK that stands out from the surface in relief, but the term also refers to the crisp, delicate textures found in smoother paint surfaces.

IMPRIMATURA

A thin, transparent GLAZE of COLOR applied to a GROUND before painting on it. This layer may be applied below or on top of an UNDERDRAWING layer. This preparatory layer not only reduces absorbency but can also be used as a MIDDLE TONE for the painting. (See illustration for OIL SKETCH.)

INCISING

The laying out by an artist of a composition on the GROUND (prior to painting) with the use of a sharp instrument to incise lines into the prepared SUPPORT. These lines may remain visible after completion of the painting as slight hollows in the paint. While the technique was sometimes used freehand, incising was most often employed to transfer a design from a CARTOON. Lines were incised with a stylus through the paper cartoon to the layer below. (See illustration for TOOLING.)

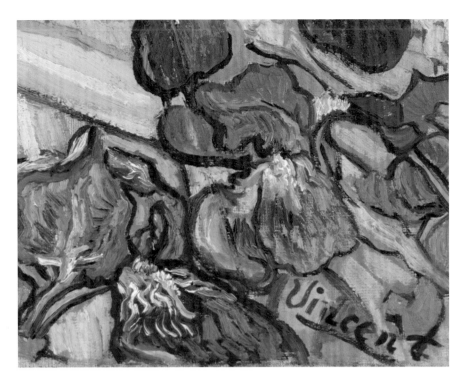

The strength of Van Gogh's brushwork is evident in the impasto in this detail from the lower right corner of the painting.

INFRARED REFLECTOGRAPHY

A modern examination technique for studying UNDERDRAWINGS and underlayers in paintings that makes use of a camera with a detector that is sensitive to infrared radiation. An image is created from the differences in absorption of infrared radiation by the materials in the painting.

Some underdrawing materials (such as charcoal or graphite) reflect light in the infrared range. When a painting is studied with an infrared camera, areas of the paint layer that do not reflect light in the infrared range become transparent, and the camera reveals the infrared reflective underdrawing; the image can be transferred to a television monitor or computer screen for viewing. Individual details can be assembled digitally, and the resultant image is called a *reflectogram*.

Before the advent of infrared reflectography, paintings were photographed with infrared-sensitive film in order to study underdrawings. However, this technique did not yield as much information as the image associated with the more sophisticated infrared-sensitive detector.

Studies of underdrawing not only can tell us a great deal about an artist's technique but also can play a role in solving problems of ATTRIBUTION.

INPAINTING See RETOUCHING.

INSCRIPTION

The incorporation of the written word into paintings as a SIGNATURE or to identify or comment on the subject(s), whether sitters in portraits or figures in complex religious, mythological, or allegorical compositions. Most inscriptions are made of simple, flat characters painted on a neutral background by either the artist or some later hand. However, inscriptions may also be incorporated illusionistically into paintings in order to appear as if chiseled in stone or written on paper. One favorite device has been the *banderole*, a scroll or ribbon that appears to float in the air or to be draped within the composition.

INTEGRAL FRAME See FRAME.

LINEN See CANVAS.

LINING

A new piece of fabric attached to the reverse of a CANVAS painting that provides additional support for the picture. Relining implies removal of an old lining canvas (and adhesive), followed by replacement with new lining materials.

During the nineteenth century, lining techniques that made use of starch paste or animal-glue adhesives were developed as a means of bonding a new piece of linen to the reverse of a painting. Moisture, heat, and pressure (from heavy irons) were used to relax distortions in both the paint film and the original canvas and to activate the adhesive. In the early decades of the twentieth century, glue or paste linings continued to be popular, but a variety of new adhesives were later introduced, including mixtures of beeswax and resin.

Many lining adhesives and techniques were designed not only to attach the new canvas to the reverse of the original but also to treat problems on the surface of the picture through impregnation of the entire structure of the painting. Although this was occasionally desirable, particularly if the paint film was in need of extensive consolidation in order to prevent further flaking or decay, such treatments have come to be less favored because of their invasive qualities. Conservators have come to value the untouched nature of unlined paintings and have developed new methods and materials that allow for treatment of structural problems without altering the appearance or character of the painting as a whole. As an alternative to lining, treatments of distortions in the original canvas or flaking of the paint surface can be made separately, and the painting can be restretched directly over a new, but unattached, piece of fabric, a technique called *loose lining*. The terms *strip lining* and *edge lining* refer to the practice of reinforcing the tacking edges of a painting with new strips of fabric, thus allowing for improved restretching of the canvas. When lining is absolutely necessary, due to the degradation of the original SUPPORT or the sheer weight of the paint film, many new, noninvasive synthetic adhesives and fabrics have been introduced that allow for the use of minimal heat and pressure.

LUNETTE

A semicircular painting, often created to be displayed over a door or a window with a vault above it. Lunettes also appear at the tops of some ALTARPIECES.

MANNER OF See ATTRIBUTION.

MAROUFLAGE

Since the nineteenth century this term has been used to describe adhering an original primary SUPPORT, such as CANVAS, to a rigid secondary support, such as a PANEL, piece of metal, or stiff board material. (The term derives from the French term *maroufler*, which means "to stick or transfer.") It is a restoration treatment that has been used for heavily damaged paintings.

Medium (pl. media)

The material that is mixed with PIGMENTS in order to create paint. The medium (or vehicle) is ultimately the material that binds the pigments to the SUPPORT. See also ACRYLIC, CASEIN, ENCAUSTIC, GOUACHE, OIL, TEMPERA, and WATERCOLOR.

Medium Analysis

The application of scientific methods to identify the binding agent present in a sample of paint. There are a number of different analytical methods used to characterize and identify both natural and synthetic media.

Megilp

A gelled paint MEDIUM that is most commonly made from the combination of oil that has been prepared with a lead drier (a compound that accelerates drying) and mastic VARNISH. As a gelled medium, megilp is easy to control in application since it moves only under the pressure of the brush. Megilp was valued for its rich translucency as a medium. It has been used with other materials, such as BITUMEN. Megilp was very popular in British painting toward the end of the eighteenth century and into the nineteenth century.

Middle tone See COLOR.

Miniature

A diminutive portrait or scene painted in any MEDIUM. The modern term derives from the Latin for vermilion, the red PIGMENT used by medieval illuminators. The exacting and highly precise technique used to create these small-scale images also derives from manuscript illumination, where the term refers to a small painting in an illustrated book. Although miniatures can assume the size of a sheet of paper, the term most often refers to paintings intended to be held in the hand.

Mixed media See MIXED TECHNIQUE and COLLAGE.

Mixed technique

The use of at least two different types of MEDIA within the same painting. In early Italian paintings, for example, the term refers to the practice of applying translucent, OIL-resin–based GLAZES on top of the more opaque EGG-TEMPERA UNDERPAINT. In later painting, the term also implies the use of an EMULSIFIED medium in which two distinctly different media (such as egg tempera and oil) have been combined into a single paint mixture.

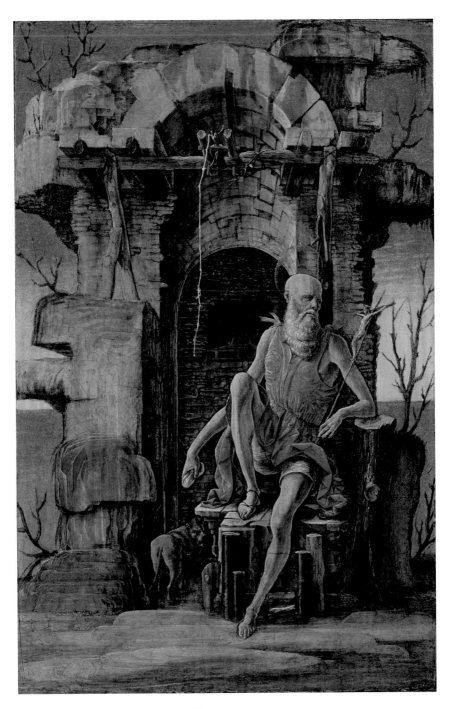

MIXED TECHNIQUE

Ercole de' Roberti (Italian, ca. 1450–1496), *Saint Jerome in the Wilderness*, ca. 1470.
Tempera on panel, 34 × 22 cm (13⅜ × 8⅝ in.). JPGM, 96.PB.14.
The sky is painted with a medium made from an oil and egg mixture.

MODELING

The representation of a three-dimensional form on a two-dimensional surface, usually achieved through the variation of light and shadow across the depicted form. This modulation of light makes the form appear solid, round, and palpable. The term *plasticity* refers to the three-dimensional quality of fully modeled figures or objects. For forms modeled with an extreme contrast between light and dark, see CHIAROSCURO; for those shaped with subtle gradations of light, see SFUMATO.

MODELLO See OIL SKETCH.

MURAL

A painting executed directly on or permanently affixed to a wall. The term is used synonymously with *wall painting*. See also FRESCO.

OIL

The general term that describes a drying oil used as a paint MEDIUM. *Oil* commonly implies the use of linseed oil, but it can also refer to several other drying oils, including walnut oil and poppy-seed oil.

Drying oils are different from nondrying oils (such as olive oil or sunflower oil) because of their unique ability to form solid films upon prolonged exposure to air. The rich, luminous nature and appearance of oils led to their use as paint media.

The use of oils as binders for PIGMENTS in paintings can be traced back to the fifth and sixth centuries. (Prior to this time, ancient references to oils discussed only their use in association with cooking, cosmetics, or medicines.) In the early Renaissance, oils were used in combination with other paint media, particularly in transparent GLAZES on EGG-TEMPERA paintings. During the fifteenth century, the techniques of oil painting were developed and refined (particularly in Northern Europe), and by the beginning of the sixteenth century oil had become the predominant painting medium.

OIL SKETCH

Originally a preparatory study in oils for another work, not necessarily in the same MEDIUM (e.g., prints, sculpture, and architecture). In the late eighteenth century, painters began making such small-scale, seemingly spontaneous pictures, particularly of landscapes, as independent works of art and not in preparation for more elaborate compositions. (See also PLEIN AIR.)

Functionally related to drawing, oil sketches were pioneered by sixteenth-century Italian painters. Usually executed on PANEL or CANVAS, but also sometimes on paper (often laid down on canvas or board), these sketches can be painted in monochrome, like GRISAILLE, or they can be fully colored. An oil sketch with particularly sketchy execution that records the painter's early ideas is sometimes called a *bozzetto*. The term *oil sketch* also encompasses the more finished *modello*, a scale model of the final composition meant for presentation to a patron for approval

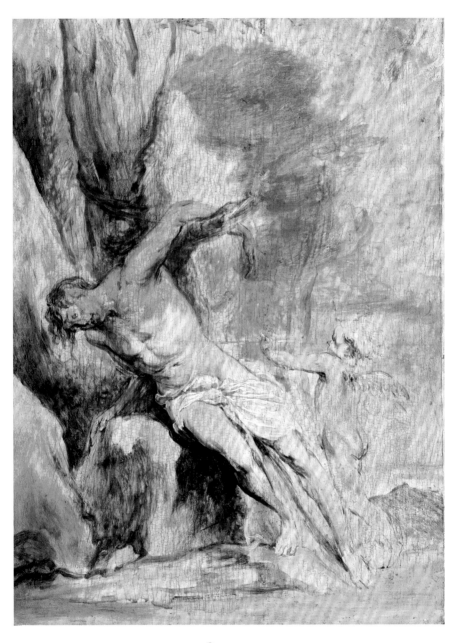

OIL SKETCH

Anthony van Dyck (Flemish, 1599–1641), *Saint Sebastian Tended by an Angel*, ca. 1630–32.
Oil on panel, 40.5 × 30.5 cm (16 × 12 in.). JPGM, 85.PB.31.

or for use in the artist's WORKSHOP in the preparation of a full-scale painting. A *ricordo* is a small oil sketch of a previously executed composition, made as a record by the artist or an assistant.

Peter Paul Rubens is especially well known for having used assistants to execute his ideas based on his prepared sketches. He is credited with raising the oil sketch from the level of a mere preliminary exercise to that of an independent work of art.

ORIGINAL

Commonly used to refer to any painting executed entirely by an artist, although more precisely indicating the first example of a painted composition subsequently repeated by the artist or by others. Before the invention of photography, painters were often called on to reproduce their most popular works. An exact duplicate is called a *replica*. Replicas were often produced by assistants working under the artist's supervision, but when they were produced by the author of the original, the terms *autograph replica* and *autograph copy* are employed. Used by itself, the term *copy* generally refers to a reproduction by a painter not connected with the WORKSHOP of the original artist. Although the use of the terminology is hardly precise, the terms *version* and *variant* usually refer to compositions produced by the artist or the artist's workshop that alter the appearance of the original; such paintings sometimes bear only a slight resemblance to the original.

OVERDOOR

A painting specially created to hang over a door, often with the PERSPECTIVE adjusted to compensate for its position high above eye level. Overdoors may include TROMPE L'OEIL representations of stone reliefs, as well as STILL-LIFE subjects in which the effect of light from a nearby source is achieved with the technique of SOTTO IN SÙ. Overdoors were sometimes painted on SUPPORTS of irregular shape to fit in FRAMES that were part of the architectural decor. See also LUNETTE.

PAINTERLY See BRUSHWORK.

PALETTE

A surface for laying out paint. Many palettes are small enough to be held in the hand (thus the classic thumbhole associated with palette designs), although they can come in almost any size and shape. Palettes can be made from any type of nonabsorbent material; wood is the traditional choice, but ceramics, metals, marble, and glass can be used.

The term also refers to the general COLOR tonality of a painting. If, for example, the colors within a painting are predominantly blue, the effect is that of a "cool palette"; on the other hand, red tones result in a "warm palette."

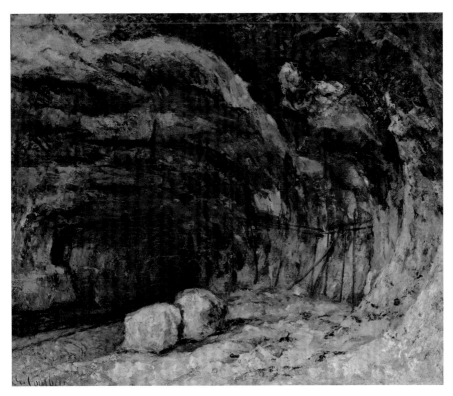

PALETTE KNIFE

Gustave Courbet (French, 1819–1877), *Grotto of Sarrazine near Nans-sous-Sainte-Anne*, ca. 1864. Oil on canvas, 50 × 60 cm (19 ¹¹⁄₁₆ × 23 ⅝ in.). JPGM, 2004.47. Courbet used a palette knife to create the textured interior of a cavern.

PALETTE KNIFE

A flat metal spatula that was originally designed for mixing pigments with a painting MEDIUM. Palette knives were eventually used, in addition to BRUSHES, as a means of applying the paint to the SUPPORT.

PANEL

A wooden SUPPORT used for a painting. Wood panels were among the earliest types of painting supports; wall paintings (the predominant form of painted decoration in ancient times) were permanent, stationary artworks, whereas use of a wood panel allowed for portability of the work of art. Wood planks could be joined together to create a support of any size or shape. Panels could be joined together using glue and then various forms of reinforcements to the join, including battens attached to the reverse of the panel or dowels inserted into carved channels along the join to help with aligning the two sides of the join. Those methods not visible to the eye can be imaged using X-RADIOGRAPHY.

Nearly all types of wood have been used at one time or another as painting supports. A few broad generalizations can be drawn regarding the popularity of certain

types of woods during particular periods. It is generally acknowledged, for example, that Italian painters of the Renaissance used poplar, whereas Northern European painters favored oak. However, the use of such diverse woods as fir, chestnut, walnut, or lindenwood, or such exotic woods as mahogany, was not unusual.

Wood types can be identified by studying the structure of the growth rings and cells in the wood. Some types of wood can be dated by *dendrochronology*, the method of using tree-growth ring patterns to correlate the growth of the tree to a specific climate in a certain period of history.

PANEL

The reverse of Francesco Salviati's *Portrait of a Man*, (p. 38). This beautifully preserved poplar panel still retains the original horizontal battens used to reinforce the support of Salviati's painting.

PASTEL

Odilon Redon (French, 1840–1916), *Baronne de Domecy*, ca. 1900. Pastel and graphite on light brown laid paper,
61 × 42.4 cm (24 × 16 11/16 in.). JPGM, 2005.1. Redon portrayed the head of the sitter in graphite and used a wide range
of pastel techniques to achieve ethereal and textured effects.

PASTEL

Crayons made from PIGMENT and filler materials held together in a soft, solid stick
form by a gum medium. Once applied, pastel colors are generally opaque. The col-
ors may be mixed together using tools such as a stump or with a brush or a finger.
Pastels can be used to imitate paint effects; they can be used to build up layers of
color and can be further mixed and manipulated to achieve effects similar to those
of paint. Pastels are applied to paper, board, and CANVAS SUPPORTS.

PASTICHE See FAKES AND FORGERIES.

PASTIGLIA

The three-dimensional ornament found on paintings or polychrome sculpture that is a result of building up form from GESSO and carving details. Pastiglia is most often GILDED and sometimes painted. (See illustration for TOOLING.)

PENDANT

A painting created as a companion piece to another painting, usually of the same size and with complementary subject and composition. For instance, pairs of portraits were often commissioned by couples, sometimes to celebrate their marriage, and different forms of landscape were often paired.

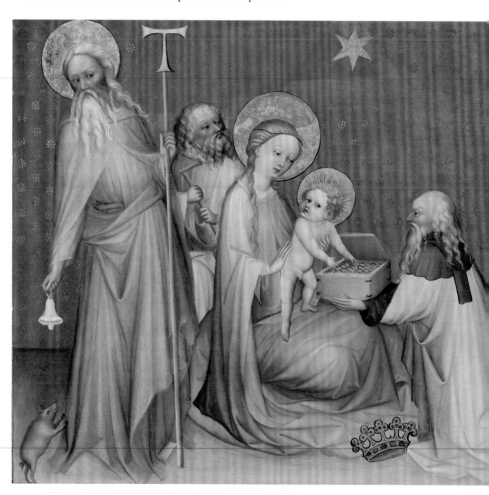

PENTIMENTO

An artist's alteration (literally, repentance or change of mind). While usually used to refer to a modification that has become increasingly apparent with time, the term may also describe a change that is visible only through scientific analysis. As an artist develops a painting, she or he may choose to alter the placement of particular elements within the composition. Although these changes are initially invisible on the finished surface of the painting, they can become visible over time, emerging as ghostlike images. This is the result of the fact that paint (in particular, OIL paint) tends to become more transparent as it ages; changes lying below the surface will become more evident as the transparency increases.

Pentimenti, like CRAQUELURE, are valued aspects of older paintings. They can provide us with a fascinating glimpse of the artist's mind at work.

PENTIMENTO
Franco-Flemish Master (act. in Burgundy, ca. 1400), *The Adoration of the Magi with Saint Anthony Abbot*, ca. 1390–1410. Oil and tempera with gold and silver leaf on panel, 104.6 × 188.5 cm (41³/₁₆ × 74³/₁₆ in.). JPGM, 2004.68.

A pentimento is visible above the Holy Family: the faint triangular shape of a roof indicates that the artist initially painted a manger in the scene.

PERSPECTIVE

The techniques of representing three-dimensional space on a two-dimensional sur-
face. Overlapping is the simplest and most ancient form of perspective. Before the
Renaissance, painters intuitively developed perspective techniques by observing
optical phenomena such as the effect of distance on the apparent size of objects.
Systematic perspective based on mathematical principles, usually called *linear per-
spective*, was developed in Italy in the early fifteenth century, as artists sought to
represent space with greater naturalism. It is based on the eye's perception that par-
allel lines converge as they recede from the spectator. In early *one-point perspective*,
all lines except those parallel to the PICTURE PLANE converge toward a single point
on the horizon line called the *vanishing point*. Later, artists plotted more than one
vanishing point to achieve greater verisimilitude.

Aerial perspective is a nonlinear means of producing a sense of depth in paint-
ing. Also called *atmospheric perspective*, it depends on the optical effects of moisture
and dust particles in the earth's atmosphere, which make distant objects appear
muted and blue. Following principles devised by Leonardo da Vinci in Italy, paint-
ers learned to represent distance by using a blue haze to subtly mute other colors
toward the horizon, making them paler and bluer.

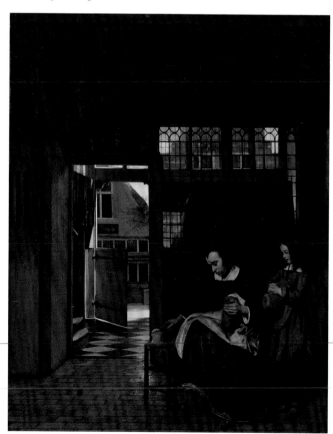

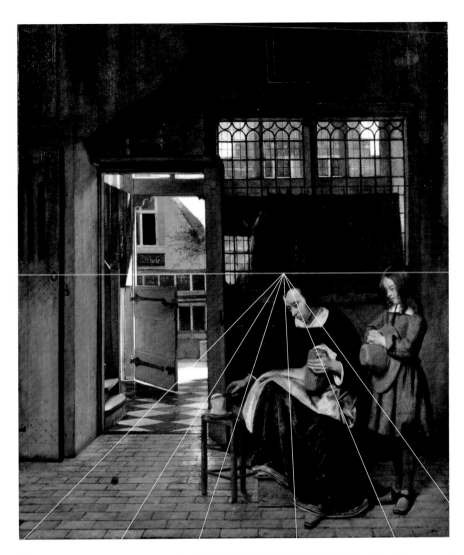

The perspective orthogonals (illustrated schematically) were established by using a string attached to a pin. The string was coated with chalk and snapped on the prepared ground of the canvas. Perspective reconstruction: Yvonne Szafran.

De Hooch marked the vanishing point with a pinhole. Photo: Yvonne Szafran.

PHOTOMICROGRAPH

Lucas Cranach the Elder (German, 1472–1553), *A Faun and His Family with a Slain Lion* (detail), ca. 1526.
(See full image on p. 24, detail on p. 25.)

PHOTOMICROGRAPH

A photograph that is taken through a microscope. When a painting is viewed through a microscope, one is able to see details of BRUSHWORK and layer structures of paint that are hard to observe with the naked eye. Photomicrographs are useful in documenting CRAQUELURE, layering techniques, and some features of PIGMENTS in the paint layer.

PICTURE PLANE

The plane separating the imaginary space of a painting delineated by its surface and the real space of the spectator. The picture plane is often likened to a glass window through which an imaginary space is revealed through PERSPECTIVE and FORESHORT-ENING. With trompe l'oeil ILLUSIONISM, objects are sometimes painted so that they appear to project through the picture plane and into real space and time.

PIGMENT

The coloring agent that is mixed with a binding MEDIUM to form paint. Pigments were originally made from clays (which could be baked or ground into fine powders, such as yellow ocher), ground minerals (such as lapis lazuli, which, when ground into a powder, produces the pigment known as ultramarine blue), and naturally occurring by-products (such as candle soot, used to make lampblack).

Pigments are also made from vegetable sources ("dragon's blood" is made from a tree bark) and animal sources ("Indian yellow" was made from the urine of cows that had been fed mango leaves).

Synthetic pigments (which are man-made) can also be traced back to ancient times: "Egyptian blue," for example, was manufactured from a combination of copper, calcium, and sand (silica). In modern times, less expensive synthetic substitutes have replaced most naturally occurring pigments.

The advent of scientific examination techniques has enabled CONSERVATION scientists to identify nearly all of the pigments used in the history of painting; this has led to the discovery that different pigments were used at different points in time. As a result, pigment identification can often be used to support or refute opinions concerning the date and origin of a particular painting. See also FAKES AND FORGERIES.

PIGMENT ALTERATION

The chemical or physical change that a pigment undergoes over time and with exposure to various climate conditions. While most pigments are stable and do not appear to change over time, there are some that are affected by lighting or climate conditions, causing them to fade, darken, or discolor. Pigments that fade on exposure to light, termed FUGITIVE PIGMENTS, are often made from organic dyes. Vermilion, a bright red inorganic pigment, can darken upon exposure to strong lighting conditions.

Other pigments occasionally undergo chemical changes related to exposure to environmental pollutants. Some types of *smalt*, a blue pigment made from glass particles, tend to turn grayish over time because of interaction with the paint binding MEDIUM and the environment. Lead white, when bound in a paint medium, is quite stable. When it is used in an underbound state in a drawing, it may darken, since the pigment particles are exposed to hydrogen sulfide in air pollution. See also FUGITIVE PIGMENT and PIGMENT.

PIGMENT ANALYSIS

PIGMENTS may be characterized by describing their size, shape, and visual characteristics through microscopic techniques. Pigment identification may be done using a variety of scientific methods that reveal the exact elemental structure of the pigment. Most techniques that identify pigments require removing a small sample from the painting. Identifying pigments can provide useful information that helps to date paintings and restoration interventions.

PINXIT See SIGNATURE.

PLASTICITY See MODELING.

Plein air

From the French term meaning "open air," the practice of painting outdoors to capture fleeting effects of light and atmosphere. While strictly employed for paintings actually executed outdoors (painting *en plein air*), the term is also used for a work strongly conveying a direct impression of nature. Thus, it may be applied to earlier landscape artists who did not habitually paint directly from nature, but it is more usually associated with late-eighteenth- and nineteenth-century painters, especially the Barbizon School and the Impressionists.

PLEIN AIR

Claude-Oscar Monet (French, 1840–1926), *The Beach at Trouville*, signed and dated: Cl.M.70.
Oil on canvas, 37.5 × 45.7 cm (14¾ × 18 in.). NGL, 3951. © National Gallery, London.
In this *plein air* painting, particles of sand and shell from the beach are embedded in the paint surface.

Polychromy

The multicolored decoration of surfaces. The term is frequently used to describe the painted surfaces of wooden and stone sculptures. Polychrome decoration was used in ancient times to decorate sculpture and sculpted architectural elements. The technique gained popularity in medieval and Renaissance Europe.

POLYCHROMY

Luisa Roldán (Spanish, 1652–1706), *Santa Ginés de La Jara*, ca. 1692. Polychromed wood (pine and cedar) with glass eyes,
175.9 × 92 × 74 cm (5 ft. 9¼ × 3 ft. ³⁄₁₆ × 2 ft. 5⅛ in.). JPGM, 85.SD.161.

POLYPTYCH

A painting comprising four or more panels, usually an ALTARPIECE, whether hinged together or arranged in a fixed architectural FRAME. A typical form consists of a principal central image flanked by side panels or wings, usually hinged to fold, with subsidiary rows or registers of panels above and below. The lower register is called the *predella* and is composed of smaller panels, often with narrative episodes from the lives of the saints depicted above. See also DIPTYCH and TRIPTYCH.

POUNCING

A method of transferring a design from a CARTOON to the prepared surface of a CANVAS, PANEL, or FRESCO. Holes are pricked along the outlines of the original design, which is then placed over the surface to be painted. *Pounce*, a fine powder of charcoal, chalk, or clay, is then dusted through the holes to mark the surface below. The technique was used for transferring whole compositions but was particularly useful for repetitive design passages, for which stencils were employed. Pounce marks can sometimes be seen on the surfaces of paintings and, if made with charcoal, such marks can be detected with INFRARED REFLECTOGRAPHY. For other transfer techniques, see INCISING and SQUARING.

PREDELLA See ALTARPIECE and POLYPTYCH.

PRIMING See GROUND.

PRIMUERSEL

A historic Dutch word used to describe the preparation of PANELS for painting. Primuersel has been used by authors to describe applying the GROUND layer to a panel as well as the IMPRIMATURA layer. Primuersel can more specifically be interpreted to refer to an OIL-bound, lead-white PIGMENTED preparation layer.

PROVENANCE

The history of the ownership of a work of art. It is sometimes possible to trace paintings back to the artist's studio, especially when the work gained immediate fame or was commissioned by an important patron. With other pictures, painstaking research is required. In addition to information provided by present and past owners, the tools of provenance include contemporary descriptions, inventories of collections, inventory numbers on the paintings themselves, and auction sales catalogues.

PUNCHMARK See TOOLING.

QUADRATURA

An illusionistic wall decoration comprising fictive architectural elements, such as balustrades, doors, columns, and arches, that incorporate or extend the architecture of the room itself. Italian Baroque artists specializing in this fictive technique were called *quadraturisti*. See ILLUSIONISM.

RELINING See LINING.

REPLICA See ORIGINAL.

RESERVE

An area left unpainted, with the original surface of the GROUND or preparation layer revealed in anticipation of another feature to be executed later; also, the process of creating a composition with this approach in mind. Areas left in reserve may sometimes be completed by another artist. Reserves may be left for any part of a composition and are often used for figures, where subtle GLAZES are used to create shadows over the preparation layer.

RESTORATION See CONSERVATION.

RESERVE

Albrecht Dürer (German, 1471–1528), *Salvator Mundi*, before 1505. Oil on wood, 58.1 × 47 cm (22⅞ × 18½ in.). New York, Metropolitan Museum of Art, The Friedsam Collection, Bequest of Michael Friedsam, 1931, 32.100.64. The Metropolitan Museum of Art/Art Resource, NY.

In this unfinished painting, the drapery was painted first and the head and hands were left in reserve. The underdrawing is visible, especially in the face.

RETABLO

A Spanish term used to describe the wooden structure that is carved and decorated to hold paintings and/or sculptures and relics. Retablos provide the decoration for altars in churches. See ALTARPIECE.

RETOUCHING

Originally, corrections or additions made by an artist as final adjustments to a completed picture. However, the term has come to identify something quite different: the work done by a restorer to replace areas of loss or damage in a painting. In the past, retouches often covered broad areas of the original painting; contemporary CONSERVATION ethics dictate that retouching (or *inpainting*) be confined to the areas of loss. Retouches are executed in a MEDIUM that differs from the original so that they can be removed easily; OIL paintings, for example, can be retouched with materials such as WATERCOLORS or synthetic resin-based paints.

Retouching is most often intended to remain invisible to the naked eye. Examination of a painting under ULTRAVIOLET light will usually reveal the presence of retouching; photographs are used by conservators to document paintings in their unretouched (or cleaned) state, and these also provide a clear record of areas that have been subsequently inpainted.

RETOUCHING
Vittore Carpaccio
(Italian, 1460–1526),
Hunting on the Lagoon
(recto), ca. 1490–95. Oil
on panel, 76 × 63.8 cm
(30 × 25⅛ in.).
JPGM, 79.PB.72.

The painting is seen here
in its cleaned state before
retouching.

Not all retouches are intended to completely disguise the losses within a painting. Different philosophies of restoration promote different approaches to retouching. The most familiar variant is *tratteggio*, a method developed in Italy and based on filling in the loss with many vertical, parallel strokes of paint (usually watercolor). In principle, this type of retouching is visible when the painting is examined at close range but blends in discreetly with the original at a normal viewing distance. Other variations on this type of retouching include the method of *integrazione cromatica* (in which an abstract pattern of overlapping strokes, drawn from the colors used in the original painting, is used to fill in the loss) and so-called neutral retouches that derive from a purist belief in the need to leave all of the damage visible on the surface. *Neutral retouching* describes flat areas of color that are painted in a single tone or combination of colors to achieve a uniform surface that makes no attempt to reconstruct the lost image.

Very few paintings have survived without incurring some sort of damage to their surfaces. Retouching, therefore, is to be expected. If it is skillfully executed, retouching will not interfere with the viewer's experience of the work of art and will have little effect on the intrinsic value of the painting.

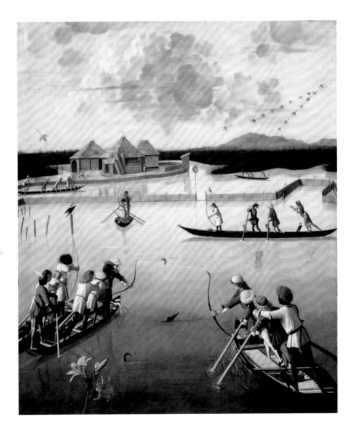

The losses and damages to Carpaccio's painting have been completely retouched.

SCALLOPING See CUSPING.

SCHOOL OF See ATTRIBUTION.

SCUMBLE

A thin, lighter layer of semi-opaque color placed over a darker UNDERPAINT. The presence of the darker underlayer will, as a rule, shift the appearance of the scumble toward a blue or cooler tone that leads to a dulling of the total color effect.

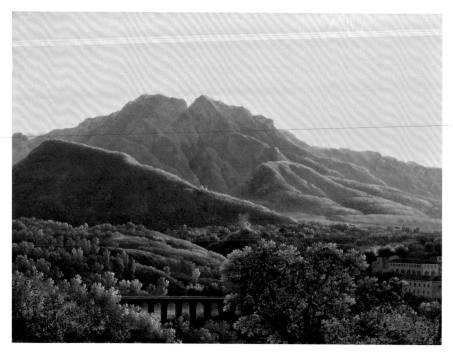

SCUMBLE

Jean-Joseph-Xavier Bidauld (French, 1758–1846), *View of the Bridge and Part of the Town of Cava, Kingdom of Naples,* 1785–90. Oil on paper laid down on canvas, 20.5 × 27.5 cm (8 1/16 × 10 13/16 in.).
JPGM, Anonymous gift in honor of John Walsh, 2001.55.
Scumbles create an illusion of depth in the cool tonalities of the mountains in the distance.

SFUMATO

The imperceptible gradation of tones or colors from light to dark in MODELING, often giving forms soft contours. The early development of the technique is tied to the naturalistic goals of the Renaissance. It is particularly associated with the paintings of Leonardo da Vinci, who wrote that light and shade should blend "in the manner of smoke" (*fumo*).

SFUMATO
Leonardo da Vinci (Italian, 1452–1519), *The Virgin of the Rocks*, 1483–1506.
Oil on panel, 189.5 × 120 cm (74⅝ × 47¼ in.). NGL, 1093. © National Gallery, London.

SIGNATURE

Jan van Eyck (Netherlandish, act. 1422–d. 1441), *"The Arnolfini Marriage"*:
Double Portrait of Giovanni di Arrigo Arnolfini and His Wife Giovanna, 1434.
Oil on oak panel, 81.8 × 59.7 cm (32¼ × 23½ in.). NGL, 186. © National Gallery, London.
The signature and inscription read: *Johannes de eyck fuit hic. 1434* ("Jan van Eyck was here, 1434").
The reflection visible in the mirror shows the painter and is a masterful example of ILLUSIONISM.

SGRAFFITO

An Italian word meaning "scratched," used to describe a method of attaining certain effects. For example, a gold cloth can be depicted by GILDING the surface of the painting and then applying paint over the metal leaf. The artist is then able to scratch through the paint layer to create a pattern, since the gold will be revealed in those areas. This technique allows for fine lines and patterns in gold that would be difficult to create by applying gold to the surface of the painting. (See illustration for TOOLING.)

SIGNATURE

While some painters habitually sign their works, others never do. Although usually a matter of personal preference, some contracts specify that the artist sign the work, especially if he or she has already achieved fame. There are many styles of signatures,

varying from true autographs to complex lettering schemes. Some painters include their full name, while others, like Albrecht Dürer, create distinctive monograms.

A signature may be included in a much longer INSCRIPTION. The letter *f* following a signature stands for the Latin *fecit*, or "made it," which is sometimes followed by the date. Similarly, *pinxit* means "painted it." Signatures may be inscribed on the PICTURE PLANE or they may be incorporated into the composition as if written on a wall or on a little piece of paper, called a *cartellino* (see the illustration accompanying ATTRIBUTE). A signature alone cannot determine the authenticity of a painting, because some artists are known to have signed works executed by others. Likewise, forged signatures are found not only on FAKES but also on authentic works. A stamp of the artist's name designed to resemble a signature and applied in the artist's studio after his death—a practice common in the nineteenth century—is not considered a signature. (For another artist's signature, see p. 43.)

SINOPIA See FRESCO.

SIZE

In the broadest sense of the term, any material used as a primer to seal an absorbent surface. Size is traditionally made from gelatin derived from animal skin and bones. CANVAS, for example, can be coated with a thin size in order to prevent OILS or resins from subsequent GROUND or paint layers from soaking through to the threads of the fabric. Sizing can also be used to stiffen a surface or to produce a smooth finish; GESSO grounds were often sized as part of the final preparation of their surfaces.

SKETCH See OIL SKETCH.

SOTTO IN SÙ

An Italian term meaning "from below upward," used with regard to illusionistic ceiling paintings to describe the extreme FORESHORTENING of figures and objects so that they actually seem to exist in the space over the viewer's head. In the first major example of this technique, Andrea Mantegna's ceiling in the Camera Picta (Mantua, Palazzo Ducale), figures seem to look down into the room from a balcony; later, most Baroque ceiling paintings would use the technique to show figures floating in space. See also CEILING PAINTING, ILLUSIONISM, and QUADRATURA.

SQUARING

A method used to transfer a design from a drawing to the GROUND of a painting when the sizes of the two works differ. A grid is applied over the drawing and a series of proportional squares are drawn on the ground. The contents of each square can then be transferred to the ground by enlargement or reduction. For other transfer methods, see CARTOON, INCISING, and POUNCING.

SQUARING

Pietro da Cortona (Italian, 1596–1669), *Christ on the Cross*, ca. 1661. Pen and brown ink, with gray-brown wash,
heightened with white bodycolor over black chalk, 40.3 × 26.5 cm (15⅞ × 10⁷⁄₁₆ in.). JPGM, 92.GB.79.
The artist used a grid to transfer the composition to a larger oval altarpiece.

STILL LIFE

An arrangement of inanimate, usually commonplace, items such as foodstuffs, dead animals, and man-made objects. In painting, still life plays a variety of roles and can convey symbolic or ALLEGORICAL meanings. This broad subject area, known from the pre-classical period, gained popularity during the seventeenth century, when it emerged as an independent GENRE.

STIPPLING See BRUSHWORK.

STRETCHER

A wooden framework for stretching, supporting, and maintaining the tautness of a piece of CANVAS. Early canvas paintings were stretched across a solid PANEL SUP-PORT, but by the seventeenth century the practice of using fixed wooden frameworks (called *strainers*) as provisional supports had been introduced; the canvas was temporarily laced onto the strainer during the execution of the painting. Tension could also be maintained in some provisional strainer types by means of adjustable pegs. The finished work was restretched onto a fixed strainer or an expandable stretcher that corresponded to the dimensions of the painted surface.

A wide variety of stretcher designs have been developed. Differences in design usually focus on the types of joins and expansion mechanisms used in the corners of the stretcher system. A stretcher with "keys," for example, makes use of small, triangular pieces of wood that fit into narrow grooves at the corners of the stretcher members; tapping these keys further into the corners will force the stretcher members to expand, thus increasing the amount of tension on the fabric support. This type of readjustment is often necessary because canvas supports expand and contract with changes in humidity.

STUDIO OF See ATTRIBUTION.

STUDY See OIL SKETCH.

STYLE OF See ATTRIBUTION.

SUPPORT

A material used as the basic underlying structure in the creation of a painting. Traditional supports include PANELS and fabrics or CANVAS, but unusual materials such as COPPER, glass, vellum, and slate have been used. Supports are chosen not only because of their practical characteristics but also because different materials will impart their own qualities to the surface of the painting.

Because of its fragility, glass has only occasionally been used as a SUPPORT for OIL or GOUACHE, chiefly in the eighteenth and nineteenth centuries. Usually the pane was intended to be viewed from the unpainted side, often via transmitted light, as in a stained-glass window.

STRETCHER

Jacques-Louis David
(French, 1748–1825),
*The Farewell of Telemachus
and Eucharis*, 1818. Oil on
canvas, 87.6 × 102.9 cm
(34½ × 40½ in.).
JPGM, 87.PA.27.

The original stretcher is
still visible on the reverse
of David's painting. The
design is typical of French
early-nineteenth-century
stretcher design. Keys are
visible in the corners.

TACKING EDGE

The edge of the CANVAS SUPPORT that is used to bend the fabric around a secondary support and attach it. Tacks have been used traditionally to secure canvases to strainers and STRETCHERS. If the artist's preparation layer extended over the entire tacking edge, then the canvas was probably prepared before it was stretched. A tacking edge may provide information about the history of the painting, telling us, for example, if the painting has been removed from its original support. Tacking edges may have CUSPING marks related to the original mounting of the canvas.

TEMPERA

A water-based paint MEDIUM that, upon drying, produces an opaque surface with a soft sheen. The most common types are *egg tempera*, which is made primarily from egg yolk (although egg white can be added), and *glue tempera* (sometimes called *distemper* or, if painted on very fine LINEN, TÜCHLEIN), which is made from animal glue.

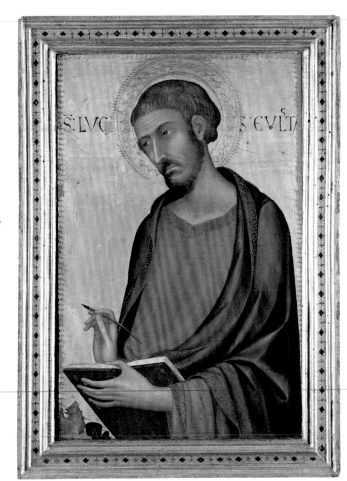

TEMPERA
Simone Martini (Italian, ca. 1284–1344), *Saint Luke the Evangelist*, ca. 1330. Egg tempera on panel, 67.5 × 48.3 cm (26 9/16 × 19 in., with frame). JPGM, 82.PB.72.

In Simone's egg-tempera portrait of the patron saint of painters, the form has been created by many parallel strokes of color.

Egg-tempera techniques were fully developed during the early Italian Renaissance. Although egg was eventually replaced by OIL as the predominant painting medium, interest in the use of egg tempera revived during the nineteenth century and has continued to this day. The medium produces a hard, durable, and somewhat lustrous surface. Egg tempera dries very quickly and cannot be brushed uniformly over broad areas; as a result, egg-tempera pictures are painted with repeated brushstrokes, visible as many small hatches on the finished surface. See DISTEMPER and TEMPERA GRASSA.

TEMPERA GRASSA

A water-based paint MEDIUM made from EMULSIFYING egg with OIL or resin to create a binding medium. Tempera grassa takes advantage of the properties of the individual components: the resin and oil slow down the drying time of the egg. Tempera grassa may be used in paintings that appear to be predominantly in TEMPERA or oil alone in order to create a different surface texture in the paint.

TINT See COLOR.

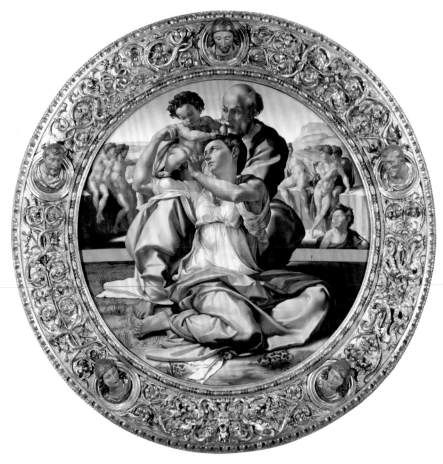

TONDO
Michelangelo Buonarroti (Italian, 1475–1574), *Doni Tondo (Doni Madonna)*, ca. 1503.
Oil and tempera on panel; diam: 120 cm (47½ in.). Florence, Galeria degli Uffizi, no. 1456. © SCALA/Art Resource.

TONDO

A circular painting whose name derives from the Italian word for "round." The format became particularly popular in Italy in the last half of the fifteenth century, when many painters took up the challenge of designing appropriate compositions for tondi, which were frequently destined for domestic settings.

TONE See COLOR.

TOOLING

The ornamentation of the gold GROUND of a PANEL after GILDING and prior to painting. To foster the ILLUSION of a solid gold ground, two metalwork techniques were adapted to make indentations in the thin gold without breaking through to the ground. Lines were INCISED using a metal stylus or compass to create halos or rays

TOOLING

Gentile da Fabriano
(Italian, ca. 1370–1427),
*The Coronation of the
Virgin*, ca. 1420. Tempera
and gold leaf on panel,
87.5 × 64 cm
(34½ × 25³⁄₁₆ in.).
JPGM, 77.PB.92.

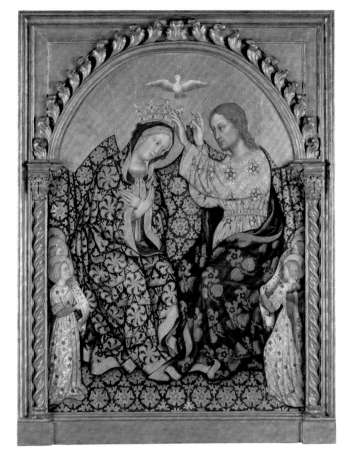

Incised lines create the
rays emanating from the
dove, and punchmarks
form the halos. The
Virgin's crown is fashioned
of pastiglia.

emanating from a saint. To form patterns in borders and backgrounds, *punchmarks* were made by lightly tapping metal punches with a hammer. For broad areas of pattern, many punches were used to create complex designs. The incised lines and punchmarks greatly enhanced surface variety by catching the light and making the gold shimmer, but the techniques were also extended to painted areas.

Styles of tooling can be quite distinctive and can be used in CONNOISSEURSHIP to associate panels with certain WORKSHOPS. Sometimes tooling was combined with PASTIGLIA, or GESSO molded in relief on the surface of the panel to enhance the simulation of precious metal.

TRANSFER

The process of removing a painting from its original, presumably deteriorated SUP-PORT (either CANVAS or wood PANEL) and replacing it with a new support. A transfer is usually made of the entire painting; however, a partial transfer may sometimes be done, in which only part of the painting is removed from the support and is then attached locally to a new secondary support.

The transfer technique was particularly fashionable during the nineteenth century as a treatment for PANEL paintings, before the advent of environmental controls. Exposure to extreme variations in temperature and humidity, such as dry indoor heat during the winter months, could cause severe splitting and cracking in a panel painting. Theoretically, the painting could be removed from its panel support and placed on a more flexible fabric support. The process involved preliminary application of a protective, reversible facing (made from layers of paper and glue) on the surface of the painting; the wood was then slowly shaved away from the back until the reverse of either the GROUND or the paint film was exposed. A new support of fabric (or wood) was attached by means of adhesives and the protective facing was removed from the surface of the painting.

Transfers were also performed on canvas paintings, if the original fabric had deteriorated irreversibly. In the twentieth century, new panels of laminated synthetic materials have been developed to replace the deteriorated wood or canvas supports.

Unfortunately, transfers invariably have a permanent visible effect on the surface of a painting. Paintings that were originally on wood can develop new (and disturbing) surface textures that result from the weave patterns of the new fabric support. Even if a transfer is executed with extreme care, subtleties in the original handling of the surface of the painting can be distorted and changed. Today, less invasive structural treatments have been developed that have nearly eliminated the need to transfer paintings; sophisticated environmental control systems (which maintain constant levels of temperature and humidity) have also played an instrumental role in preserving original supports.

TRATTEGGIO See RETOUCHING.

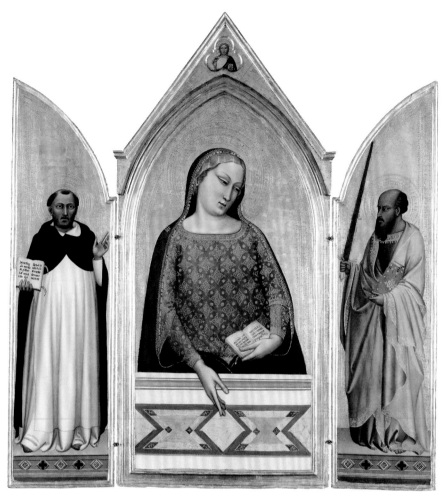

TRIPTYCH

Bernardo Daddi (Italian, ca. 1280–1348), *The Virgin Mary with Saints Thomas Aquinas and Paul*, ca. 1330.
Tempera and gold leaf on panel; with frame: 120.7 × 55.9 cm (47½ × 22 in.). JPGM, 93.PB.16.

TRIPTYCH

A picture comprising three PANELS, usually hinged together. In its most common form, the central panel was twice the width of the outer panels (or *wings*) so that they could be folded over to close the triptych and protect the images. When the panels were made to be closed, the exterior surfaces were also decorated. Like the DIPTYCH, the triptych was a popular form of portable devotional object, but it was also commonly used on a large scale for altarpieces. One standard form employed an image of the Virgin and Child on the central panel, with the donor's patron saints on the wings. See also ALTARPIECE and POLYPTYCH.

TROMPE L'OEIL See ILLUSIONISTIC/ILLUSIONISM.

TÜCHLEIN

A term that describes painting in a water-based MEDIUM of EGG TEMPERA or DIS-TEMPER directly onto the CANVAS. Often the canvas texture of a tüchlein figures prominently, since there is no preparation layer that smoothes out the surface of the canvas SUPPORT.

Because the medium has been absorbed into the canvas, the surface of a tüchlein painting is typically very matte in appearance, as well as flexible. These paintings were not varnished, since a VARNISH coating would significantly alter the color of the matte paint.

Tüchlein paintings are very fragile and often are not well preserved because of damage from handling, as well as from improper treatment through varnishing and varnish removal.

In the Middle Ages and Renaissance, processional banners were often tüchlein paintings.

TURBID MEDIUM EFFECT

An effect produced in the layering of paint when a light-colored paint is thinly applied over a warm, darker underlayer in order to produce a very cool effect in the top paint layer. When the turbid medium effect is used, the top layer appears cooler than if it were painted over a lighter underlayer. This technique was used extensively by Rembrandt in painting shadows in flesh tones.

ULTRAVIOLET

A scientific aid in the examination of paintings. Because different painting materials exhibit characteristic fluorescence colors when exposed to ultraviolet light, ultraviolet illumination can be used to identify areas of RETOUCHING and to determine different types of VARNISH.

In this process, a painting is brought into a darkened room and then lit with ultraviolet light. Areas of recent retouching will often appear as a dark purple, in

ULTRAVIOLET
Jusepe de Ribera
(Spanish, 1591–1652),
A Philosopher, ca. 1630–35.
Oil on canvas, 125 × 92 cm
(49 ¼ × 36 ¼ in.). JPGM,
2001.26.

Ribera's painting, after
treatment, in normal
light. See next page.

On the left, Ribera's painting (previous page) is shown before treatment, with aged and discolored varnish layers. On the right, the discolored varnish layers flouresce green in ultraviolet light, except in the face and beard, where varnish has been removed.

stark contrast to the lighter, greenish appearance of the old varnish. Different types of varnish may exhibit characteristic features under ultraviolet light. (Shellac, for example, fluoresces a bright yellow-orange.) Identification of certain PIGMENTS (such as natural madder lakes, which are deep, transparent violet-reds made from natural dyes) can occasionally be made from their individual fluorescence colors.

Ultraviolet light is also used to view CROSS SECTIONS using a microscope, since the materials present in the sample may fluoresce colors typical of certain materials. Natural resin varnishes, for example, fluoresce green.

UNDERDRAWING

A preparatory drawing directly on a GROUND, which is subsequently covered with paint. Such drawings are often executed with charcoal, chalk, pencil, or paint. Depending on the artist and the function of the picture, underdrawings can range from quickly sketched outlines to quite detailed renderings. Until recently, this type of drawing was visible to the naked eye primarily in unfinished works or when thin paint layers became more transparent over time. The technique of INFRARED REFLECTOGRAPHY has made it possible to view some underdrawings through the paint layer. The study of the changes made between the drawing and the painted image allows us to observe the creative process of the painter in greater detail than ever before.

UNDERDRAWING

Albrecht Altdorfer (German, ca. 1480–1538),
The Crucifixion, ca. 1518. Oil and gold leaf
on panel, 75 × 57.5 cm (29½ × 22⅝ in.).
Budapest, Szépmüveszeti Múzeum.

The painting is seen here with infrared
reflectography. In the infrared reflectogram, the
underdrawing is visible in the body of Christ.

UNDERPAINTING

A preparatory paint layer applied by the artist as a means of establishing basic areas
of light, dark, or COLOR within a composition. Because the appearance of even the
most opaque paint MEDIA will be affected by underlying paint layers, underpainting
is crucial to the development of a picture and to the character of the finished sur-
face. Underpaints intended to play a major role in the final appearance of the surface
may be covered with thin GLAZES or SCUMBLES.

The term *dead coloring* refers to an artist's initial blocking in of broad areas of
underpainting.

VALUE See COLOR.

VANISHING POINT See PERSPECTIVE.

VARIANT See ORIGINAL.

VARNISH

A coating applied to the surface of a painting. The varnish layer plays a dual role: it has a profound effect on the final appearance of the painting and also serves as a protective coating for the paint surface.

The variety of varnishing materials is as diverse as the choices of paint MEDIA and techniques throughout the history of painting. The benefits of using a clear resin as a final coating for a surface were realized during antiquity; waxes, for example, have been found on the surfaces of ancient wall paintings and must have been chosen because they produce a uniform, luminescent sheen on the surface. By the early Renaissance, a variety of materials had been developed for use as painting varnishes, ranging from egg white to sandarac resin (obtained from North African pine trees). Tree resins (such as mastic and dammar), fossil resins (such as copal), and insect excretions (such as shellac) eventually became the types of materials most frequently chosen for use as varnishes. Complicated OIL/resin mixtures (made with such drying oils as linseed oil) were also developed as varnishes, although these mixtures are considered undesirable because of their tendency over time to become very discolored and virtually insoluble (making them extremely difficult to remove). Many of these natural materials are still in use by artists and restorers; numerous synthetic varnishing materials have also been developed that provide a wide array of surface characteristics.

Varnishes may be applied as a temporary measure or with the intention of providing long-lasting saturation and protection of the surface. The materials used to varnish paintings typically have a solubility different than paint's, so that a varnish can be removed without damaging the paint layers.

Although varnishes are traditionally clear, they can be toned or altered with the addition of PIGMENTS and other materials. Varnishes also tend to darken and discolor with time, necessitating their removal and replacement. This cleaning process is made technically possible as a result of the difference in solubility between the soft, easily dissolved varnish and the harder medium of the aged paint film. Many of the recently introduced synthetic varnishes have the added advantage of remaining stable and unchanged in appearance over time. Additives for natural varnishing materials have also been developed to prevent discoloration, thus reducing the need for frequent removal and replacement of varnishes.

On a microscopic level, a varnish coating fills in the tiny gaps and spaces in the upper layer of a paint film, providing a uniform surface for the reflection of light. As a result, the pigments within the painting become deeper, or more saturated, in appearance. Variable aspects of varnishes, such as the level of gloss and the thickness

of the coating, are controlled by the artist or restorer. Some paintings (such as Dutch seventeenth-century landscapes) need highly saturated, rich surfaces, while others (such as Italian EGG-TEMPERA paintings) need a soft matte sheen.

Many paintings are best left without any sort of varnish coating. The Impressionists preferred to leave their paintings unvarnished, as they believed that a resinous coating interfered with the freshness and spontaneity of the paint surface. During the twentieth century, many artists placed much importance on small variations in texture and gloss within their paintings; an overall varnish coating would tend to homogenize these fragile surfaces and eliminate such subtle effects. (See illustrations for CROSS SECTION and ULTRAVIOLET.)

VERSION See ORIGINAL.

WALL PAINTING See MURAL.

WARP

A curved distortion in a material. PANELS often develop warps as the wood moves in response to fluctuations in temperature and humidity. Many old panel paintings have slight outward curving warps because the back of the panel has absorbed and released moisture more readily than the front, which is sealed with paint layers and varnish. If a panel painting is made up of a few pieces of wood, each panel may behave a little differently. If a panel painting is restrained, it may lead to the development of a warp. See CRADLE.

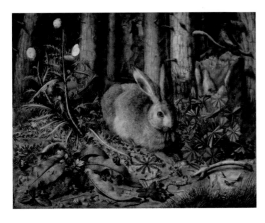

WARP

Hans Hoffmann (German, ca. 1530–1591/92), *A Hare in the Forest*, ca. 1585. Oil on panel, 62.2 × 78.4 cm (24½ × 30⅞ in.). JPGM, 2001.12.

Originally flat, this panel (seen here from the side) developed a pronounced warp over time. Photo: Jack Ross.

WATERCOLOR
Paul Cézanne (French, 1839–1906), *Still Life with Blue Pot*, ca. 1900.
Watercolor over graphite, 48 × 63.1 cm (18 15/16 × 24 7/8 in.). JPGM, 83.GC.221.

WATERCOLOR

In the term's most general sense, any paint with a water-soluble MEDIUM. However, the term usually refers to a type of painting with translucent washes of paint made from PIGMENTS suspended in a solution of gum arabic and water. Watercolors are executed on paper or on a white or light-colored GROUND that allows the most light to be reflected off the SUPPORT through the transparent washes. Highlights are often attained by thinning the paint with water so that the ground shows through, rather than using an opaque white, as is done with another water-based paint, GOUACHE.

WET-IN-WET

Application of paint to a layer of paint that has not yet dried. This approach allows the artist to blend layers of paint together to achieve different colors or textural effects.

WINGS See ALTARPIECE and POLYPTYCH.

WORKSHOP

The place where a painter works, and also the group of artists, artisans, and apprentices working for a master painter. The successful painter might require a large space and a number of assistants to accommodate the production of many paintings at the same time. The medieval guild's system of apprenticeship established the workshop

as a center for the education of the artist. Records of some workshops in the Renaissance and Baroque periods indicate that they functioned as early academies.

The quality of paintings produced by workshops has varied greatly, depending on the degree of supervision by the artist. Some artists clearly demanded a relatively high level of execution from their shop or studio, while others accepted far less; some became more involved, RETOUCHING the work of assistants to make it their own. Shop productions were often sold as the master's work because invention was deemed more important than execution, but the value we attach to ORIGINAL works has long been shared by artists and CONNOISSEURS. Today, the ATTRIBUTION of a painting to the workshop of an artist usually signifies an unknown contemporary working closely with him or her.

X-RADIOGRAPHY

A scientific tool used in the examination of paintings. To create an X-ray image (known as a radiograph), a sheet of X-ray-sensitive film is first placed in contact with the surface of the painting. Low-voltage X-rays are generated at an X-ray source and pass through the painting, registering an image that appears on the film after photographic development. The image results from the fact that different PIGMENTS

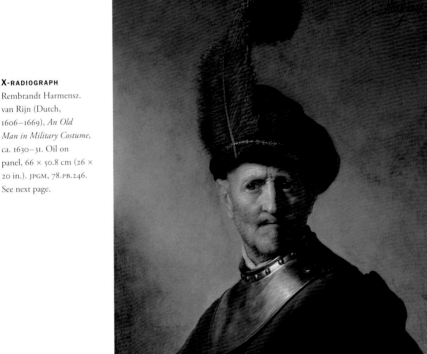

X-RADIOGRAPH
Rembrandt Harmensz.
van Rijn (Dutch,
1606–1669), *An Old
Man in Military Costume*,
ca. 1630–31. Oil on
panel, 66 × 50.8 cm (26 ×
20 in.). JPGM, 78.PB.246.
See next page.

(which have different densities) will variably affect the quantity of X-rays that are allowed to pass through the film. The lead in lead white, for example, is a very dense element and will prevent penetration of the X-rays; areas containing lead white will read as lighter regions on the radiograph. Less dense pigments, such as earth tones, allow for the passage of more of the X-rays and will read as darker areas in the radiographic image.

X-rays are very helpful in revealing losses in the original that may not be immediately visible to the naked eye, as well as original changes that may have occurred during the different stages of development of the painting. See also PENTIMENTO.

ZWISCHENGOLD

A German word used to refer to metal leaf that is made partly of gold and silver in combination. A thin sheet of gold is beaten onto a thicker sheet of silver in order to obtain a single sheet of metal leaf. The color of the gold is slightly cooler than pure gold due to the presence of the silver. Less expensive *Zwischengold* was a substitute for pure gold leaf in decorating the surfaces of European paintings, FRAMES, and sculpture.

Selected Bibliography

ARMENINI, GIOVANNI BATTISTA. *On the True Precepts of the Art of Painting*. Edited and translated by
Edward J. Olszewsky, 1977. A sixteenth-century manual for the painter.

BOMFORD, DAVID, et al. *Art in the Making: Impressionism*. Exh. cat. London, National Gallery, 1990–91.
This and the following two entries are the catalogues for groundbreaking, in-depth exhibitions on
painting techniques.

———. *Italian Painting before 1400*. Exh. cat. London, National Gallery, 1989.

———. *Rembrandt*. Exh. cat. London, National Gallery, 1988–89.

CARLYLE, LESLIE. *The Artist's Assistant*. London, 2001.

CENNINI, CENNINO. *The Craftsman's Handbook*. Translated by Daniel V. Thompson Jr., 1933. Reprint. New
York, 1960. A fifteenth-century manual for the painter and gilder.

CHILVERS, IAN, AND HAROLD OSBORNE, eds. *The Oxford Dictionary of Art*. Oxford and New York, 1988.

CROOK, JO, AND TOM LEARNER. *The Impact of Modern Paints*. London, 2000.

DOERNER, MAX. *The Materials of the Artist and Their Use in Painting with Notes on the Techniques of the
Old Masters*. Translated by Eugen Neuhaus, 1934. Reprint. New York, 1962. An English translation of
Doerner's classic *Malmaterial und seine Verwendung im Bilde*, first published in 1921.

EASTLAKE, SIR CHARLES. *Methods and Materials of Painting of the Great Schools and Masters*. New York,
1960. A reprint of *Materials for a History of Oil Painting* (London, 1847–49).

GETTENS, RUTHERFORD J., AND GEORGE L. STOUT. *Painting Materials: A Short Encyclopedia*. New York,
1966. The unsurpassed technical study of supports, media, and pigments.

KIRSH, ANDREA, AND RUSTIN S. LEVENSON. *Seeing through Paintings: Physical Examination in Art Historical
Studies*. New Haven, 2000.

MAYER, RALPH. *The Artist's Handbook of Materials and Techniques*. 4th rev. ed. New York, 1981. A useful ref-
erence tool for the contemporary painter, with references to the techniques of the past.

MURRAY, PETER, AND LINDA MURRAY. *The Penguin Dictionary of Art and Artists*. 6th ed. London and New
York, 1989.

NADOLNY, JILLEEN. "European Documentary Sources before c. 1550 Relating to Painting Grounds Applied
to Wooden Supports: Translation and Terminology." In *Preparation for Painting: The Artist's Choice and
Its Consequences*, edited by Joyce H. Townsend, Tiarna Doherty, Gunnar Heydenreich, and Jacqueline
Ridge, pp. 1–13. London, 2008.

———. "Some Observations on Northern European Metalbeaters and Metal Leaf in the Late Middle Ages."
In *The Materials, Technology, and Art of Conservation*, edited by R. A. Rushfield and M. W. Ballard,
pp. 134–60. Conservation Center of the Institute of Fine Arts, New York University, 1999.

STOUT, GEORGE L. *The Care of Pictures*. 1948. Reprint. New York, 1975.

THOMPSON, DANIEL V. *The Practice of Tempera Painting*. New York, 1962.

VASARI, GIORGIO. *Vasari on Technique*. Translated by Louisa S. Maclehose, edited by G. Baldwin Brown.
New York, 1960.

VELIZ, ZAHIRA, ed. and trans. *Artists' Techniques in Golden Age Spain: Six Treatises in Translation*. Cambridge
and New York, 1986.

Index

Note: Page numbers in **boldface** indicate main topics. Page numbers followed by the letter *f* indicate illustrations.

A
abrasion, **1**
acrylic, **1,** 31, 46
aerial perspective, 56
after, 4
alla prima, **2,** 2*f*
allegory, **2–3,** 3*f*, 4, 40, 72
altarpiece, **4,** 32, 45, 62, 64
ascribed to, 4
atmospheric perspective, 56
attribute, **4,** 5*f*
attribution, **4,** 7, 18, 43, 87
au premier coup, 2
authenticity, 4
autograph, 4
autograph copy, 50
autograph replica, 50

B
barbe, **6**
binder. *See* medium
bitumen, **6**
bodycolor, **6,** 71*f*
bole, **6,** 36–37, 36*f*
bozzetto, 48
brush, **7**
brushwork, 2, **7–8,** 8*f*, 9*f*, 42, 43*f*, 58

C
cabinet picture, **8**
canvas, 1, **10,** 10*f*, 11*f*, 27, 45, 72, 80
cartoon, **12,** 12*f*, 42, 62
casein, **13,** 46
cassone painting, **13,** 13*f*
ceiling painting, **14–15,** 14*f*, 15*f*, 41, 70
chiaroscuro, **15,** 15*f*
circle of, 4
collaboration, **16,** 16*f*
collage, **17,** 17*f*
color, **17–18**
color field painting, **18,** 19*f*
connoisseurship, 4, **18,** 78
conservation, 6, **20,** 45, 59, 64–65
copper, 8, **20,** 21*f*, 72
copy, 50
cradle, **22–23,** 22*f*, 23*f*
craquelure, 6, 20, **24–25,** 24*f*, 25*f*, 58
cross section, **26–27,** 26*f*, 82
cusping, **27,** 74

D
dead coloring, **27,** 27*f*, 83
diptych, **28,** 28*f*–29*f*, 79
direct painting, 2
distemper, **29,** 74, 80
drying oil. *See* oil

E
egg tempera, 8, 13, 46, 74–75, 80
emulsion, 1, **30–31,** 46
encaustic, 30*f*, **31,** 46
engaged frame, 6, 32–33

F
fakes and forgeries, **31,** 70
fecit, 70
follower of, 4
foreshortening, **32,** 32*f*, 41, 58, 70
frame, **32–33,** 33*f*
fresco, 12, 32, **34–35,** 34*f*
fugitive pigment, 20, **35,** 35*f*, 59

G
genre painting, **36**
gesso, **36,** 54, 78
gilding, 7, **36–37,** 36*f*, 69, 76, 79*f*, 88
glass, 72
glaze, 6, **37–38,** 37*f*, 38*f*, 42, 46
glue tempera, 74
gouache, 6, **39,** 46, 72, 86
grisaille, **39,** 39*f*, 48
ground, 20, 26, **40,** 62

H
half-tone, 18
handling. *See* brushwork
history painting, **40**
horizon line. *See* perspective
hue, 18

I
iconography, **40**
illusionistic/illusionism, 15, 18, 32–33, **41,** 41*f*, 63, 70
impasto, 7, 31, **42,** 42*f*, 43*f*
imprimatura, **42,** 62
incising, 12, **42,** 76–78, 77*f*
infrared reflectography, **43,** 62, 82, 83*f*
inpainting, 64
inscription, **44,** 44*f*, 70
integral frame, 32–33

L
linen. *See* canvas
lining, **45**
lunette, **45**